Norman Jacobs and Kerry O'Quinn present

SPECIAL EFFECTS
VOL. 1

By David Hutchison
Art Director: Robert P. Ericksen
Designer: Phyllis Cayton

Managing Editor: Bob Woods
Assoc. Designer: Elaine Ashburn-Silver
Art Assistant: Laura O'Brien
Editorial Assistant: Barbara Krasnoff

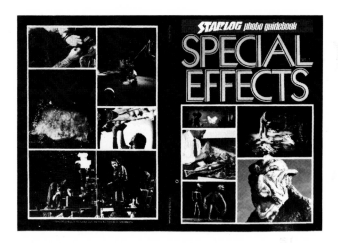

ABOUT THE COVER:

Front Cover, clockwise from top right: 1) Brian Johnson sets up the spaceship graveyard scene from the *Space: 1999* episode, "The Metamorph." Chilled CO_2 fog covers the floor of the crater, while Johnson adds touches of titanium tetra-chloride—a chemical which forms a white vapor on contact with air. The models are by designers Johnson and Martin Bower; 2) The "Great God Porno" from *Flesh Gordon*—built on part of an armature by the late Pete Peterson, it went through the hands of Laine Liska, David Allen and Bob Maine before appearing in his final animated form; 3) David Allen's lizard man and armature from his production of *The Primevals*; 4) Disney "imagineer" displays a model of the *Nautilus* before a painting of the island of its birth—Captain Nemo's secret hideaway, Volcania: 5) Derek Meddings' special-effects crew for the TV series *UFO*. Here he films the destruction of a UFO in Earth's atmosphere.

Back Cover, Clockwise from top right: 1) On the special-effects unit of Luigi Cozzi's *Adventures of Stella Star* or *Starcrash*, one of the two floating cities built for the film. The model was hastily constructed and painted silver so that color effects could be achieved with lighting; 2) Joe Viskocil places the explosive charge on the model of the rebel blockade runner from *Star Wars*. The blockade runner is attacked by an Imperial Destroyer at the beginning of the film. Model design is by Joe Johnston, construction by Grant McCune; 3) Luigi Cozzi (at lower right with hand on hip) oversees the filming of the *Murray Leinster* from his *Stella Star*; 4) From *Joe 90*, Derek Meddings; spectacular explosion of a military base; 6) Model animator David Allen moves the great creature from *Flesh Gordon*, bit by bit, for a stop-motion animation sequence.

STARLOG Magazine
O'Quinn Studios, Inc.
Norman Jacobs/Kerry O'Quinn
475 Park Avenue South
New York, N.Y. 10016

Preface

This first volume of *Special Effects*, part of the STARLOG Photo Guidebook Series, takes a behind-the-scenes look at the design and construction of the models and miniature sets created for several famous and not-so-famous science-fiction and fantasy films. Uniquely, STARLOG has decided to rely on large color pictures supported by short captions to tell the story, since there are already many written texts in print covering the various aspects of the art and technique of special effects. Almost without exception these books are limited to small black-and-white illustrations. In *Special Effects*, every attempt has been made to avoid the usual glut of publicity stills that normally make up the greater part of the illustrations of this sort of book; in some cases it was unavoidable, at other times the special-effects artists themselves took the time to record on film their work in the studio. The latter section of the book presents an in-depth look at three large-scale special-effects creations: the *Nautilus* from Disney's *20,000 Leagues Under the Sea*, Robby the Robot and the C-57 saucer from *Forbidden Planet*. Some of this material has been seen before, but much is previously unpublished. The Index lists both titles and artists mentioned in the captions and shown in photos, making specific references easy to find.

David Hutchison
STARLOG Magazine

Acknowledgement

This photo guidebook could not have been assembled without the generous assistance of the science-fiction/fantasy collectors, and the special-effects artists themselves, who took the time to lend photographs from their collections and tell the stories behind them. My personal thanks to: David Allen, Gerry Anderson, Bob Burns, Luigi Cozzi, John Dykstra, Ronald T. Gallant, Paul Gentry, Harper Goff, Ray Harryhausen, David Hirsch, David Houston, Robert Maine, Paul Mandell, Bill Malone, Grant McCune, Derek Meddings, Mike Minor, Brick Price, Tom Scherman, Joe Viskocil, Gene Warren and Wade Williams.

Contents

Index

TITLES

ARTISTS

Note: Bold-faced page numbers denote illustrations.

Introduction

Special effects is the branch of the cinematic art that is called upon to create the impossible. A shot may be considered "impossible" for normal cinematography for a variety of reasons: too dangerous, too expensive, not enough time to do it, it cannot or does not yet exist. Generally speaking, special effects has two main branches or subdivisions— special photographic effects and mechanical effects.

Mechanical effects include the broad range of live, on-set effects: rain, fog, smoke, cobwebs, trapdoors, explosions or almost any sort of special mechanical prop such as robots or an automobile that converts into a submarine or a boat that converts into a hovercraft. Historically, mechanical effects are an extension of stage effects, particularly those designed for the Restoration theatre and the melodramas of the late 19th century.

The ancient Greeks, particularly the Athenians, were great lovers of mechanical inventions. Palace kings, temple priests and even the Greek theatre made extensive use of marvelous mechanical contrivances. Heron of Alexandria (his exact birth and origin are unknown, though he is variously placed between 2 B.C. and 3 A.D.) records many marvelous devices. Indeed, statues could be made to flow with milk and wine, flames would appear on altars, drums and cymbals would sound, all without human assistance— or so it was made to appear.

The 19th century theatre-goer witnessed remarkable special effects: buildings engulfed in flames and crumbled to ash; ships under full sail at sea in the gale of a storm; railroad scenes with engines and cars traveling across the stage under full steam; horse races with live horses going at full gallop with the scenery racing by, yet never leaving the sight of the audience; the complete destruction of the temple in *Samson and Delilah*—all on the proscenium stage, live and performed night after night.

Yet, as Lee Zavitz has remarked, if you wanted to find out who the marvelous craftsmen, engineers and artists were that made these marvels possible, you had to look at the small print *after* the listing of

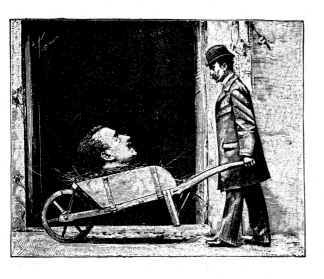

the company hairdresser, if they were listed at all!

Special *photographic* effects began with the early days of still photography. Popular novelties of the time included pictures of one's wife or beloved apparently corked inside a tiny bottle, or perhaps a man could be seen wheeling his head down the street in a barrow or seated at a table for dinner and discovering that his own head was being served to him on a platter.

Such parlor novelties were explored by many of the early innovators; perhaps the one that is most well-known is George Melies. Though Melies was a stage craftsman and many of his films relied on photographed mechanical effects, there are some "trick" films which depended solely on the photographic process to achieve their effects.

The distinction between mechanical effects and photographic effects begins to become most apparent in Melies films. The mechanical special-effects artist is concerned with creating the illusion that an event is occuring in reality. He must mechanically build devices that seem to make buildings burst into flames, etc. The photographic-effects artists create images on film that may have no substance in reality whatsoever. Consider the climactic scene in *Crossed Swords*, for example, in which a single actor plays both the prince and the pauper, yet appears in both roles on the screen at the same time shaking hands with himself! It never physically happens, or could happen, yet there it exists, *photographically.*

While these two examples represent clear-cut distinctions, there is much overlapping of the two fields. Generally, however, photographic effects refers to superimposition, traveling matters, front and rear projection, etc. Sometimes you will see photographic effects broken down into subdivisions in the credits: process photography, optical effects, matte artist. But a good special-effects artist needs to have knowledge of all areas in order to be proficient at his craft.

Nowadays, much more individual recognition is given the special-effects artist. In the days of the big studios, the practice was to list only the department heads in the credits—whether or not the department head had actually done the work, he was responsible for it, so his name and *only* his name appeared. That situation has become less of a problem since special-effects artists have begun to free-lance and the big studios systems have closed their special-effects departments.

STARLOG magazine's use of the term "special effects" is very broad. The SFX series that appears in STARLOG includes such diverse fields as matte paintings, sound effects, miniature explosions, prosthetic makeup effects, models, optical effects, stunts and many other areas not normally considered special effects in the strictest usage of the word. STARLOG includes these for the purposes of the magazine and because they are all tools used to produce the magical illusion that what we are seeing on the screen is real. Whether we are watching some alien creature, the surface of a planet a hundred light-years from Earth, or the interior of a starship as it passes the speed of light, in each instance, some artist or craftsman has created the "impossible," and for the span of a couple of hours in a darkened theatre, has allowed us to see and experience the vision of his mind.

The
Model Shop

Modelmaking is a hobby that strikes one as a youth and often becomes a burning passion for a year or even a couple of years. A 12 year old's bedroom is often cluttered with models assembled from plastic or balsa wood kits. Sometimes, that hobby blossoms into a life-long effort. Some of the young craftsmen grow up to become the special-effects artists who build the spaceships, aircraft, landscapes, flying saucers and dinosaurs for films of adventure and fantasy that the rest of us stand in line to watch. The average Hollywood model shop is a clutter of fascination. Tools as delicate as any surgeon's have been brought to bear in a world that is as disarrayed, with scattered pieces of wood, plastic and glue, as a surgeon's operating room is orderly. Browse through these pages at pictures of models being built, some complete, some with just their skeleton showing. Visit a world that few see and marvel at the craftsmanship of the works in progress as well as completed jobs.

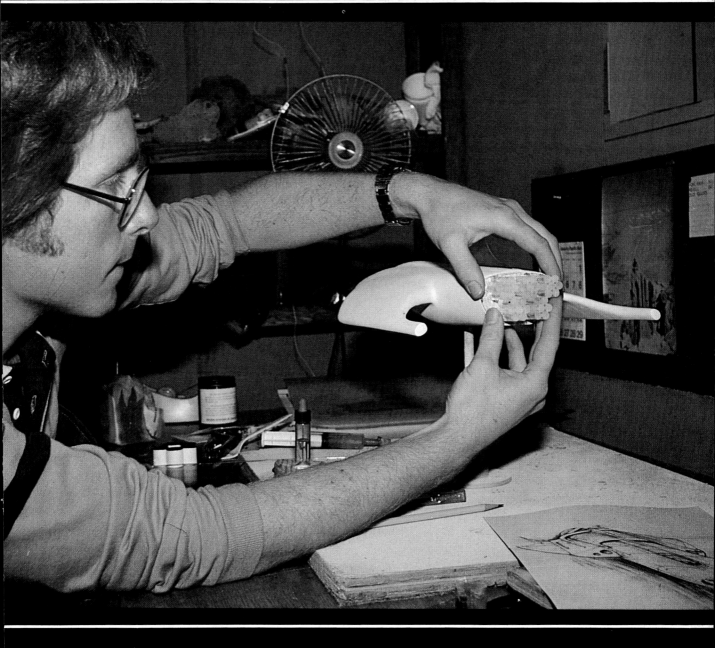

John Grusd, modelmaker and designer for Filmation Associates, checks a rocket exhaust fitting made of plastic rodding for Ming's warship. Though the Filmation version of *Flash Gordon* is cel animated, three-dimensional models are being constructed to guide the animators. It is important that the movements of the craft work in perspective. The white models are painted with narrow black lines and filmed with a motorized multi-axis camera system. The black-and-white negative is printed by a Xerox machine which produces an individual cel for each frame of film—accurately recording the motion of the ship as it turns and moves in space. These cels will serve as a guide to the animators. Paul Huston, who worked on *CE3K* and *Jason of Star Command*, was part of this team.

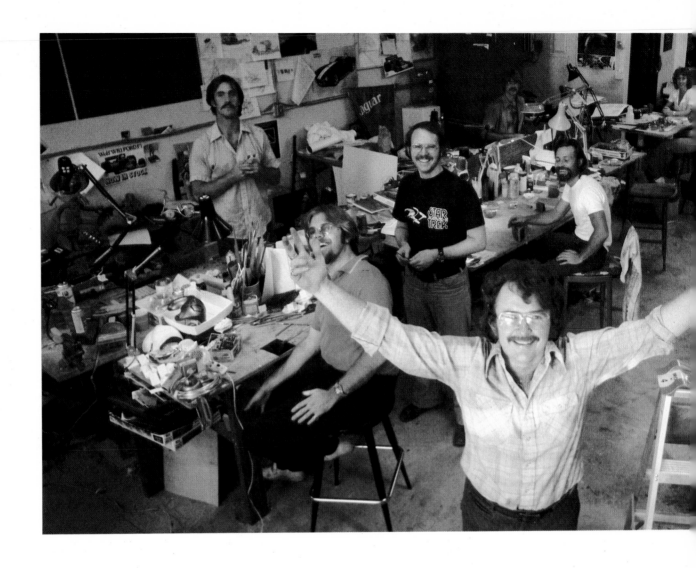

Brick Price Movie Miniatures (**above**) just prior to the first of the company's two planned moves to larger facilities. BPMM is probably most famous for its alien spacecraft on TV's *Project U.F.O.* and the hand props for *Star Trek—The Motion Picture.* BPMM is quickly garnering a reputation for extremely high-quality and imaginative work. From left to right are: Cory Faucher, Paul Laxineta, Bruce MacRae, Alan Faucher, Ron Pusich, Laura Price, Tracy Faucher and Brick Price in front. Reversing their usual method of creating things in miniature, BPMM supplied some oversize props for Universal's *The Incredible Shrinking Woman.* "This is actually harder than miniaturizing," says Price. "When you make things oversize you have to see the mold marks, flashing—all the ragged edges." BPMM is also developing 1/20th scale dinosaurs for museum dioramas, designing book jackets using photographed models, doing cartoons to advertise "Kryptonite," working with Carl Sagan on his *Man of the Cosmos* TV series, making models for the kit companies (Revell, Bolink and AMT), supplying animation and models for various commercials . . . model shops are busy places.

Joe Viskocil (**upper right**) attaches plastic foilage to resin cast tree trunks. The plastic foliage is available in variou sizes and is nearly indestructible. Many years ago foliage on sets often faded and wilted under the hot studio lights o conversely, would start to grow! These trees are being assembled for TV's *Land of the Lost.*

Starcrash (**lower right**) or *The Adventures of Stella Star* ha to begin shooting with no preparation at all. Two day before shooting was to begin in September 1977, n props had been made. Director/writer Luigi Cozzi hired 9 technicians to build props and models for his film; all the prop were built in two days! Miniature ships were built by a fe Italian youths led by 20-year-old Paol Zeccara, from designs b illustrator Niso Ramponi. The models were spray painte silver and illuminated with colored lights because of th shockingly short time schedule.

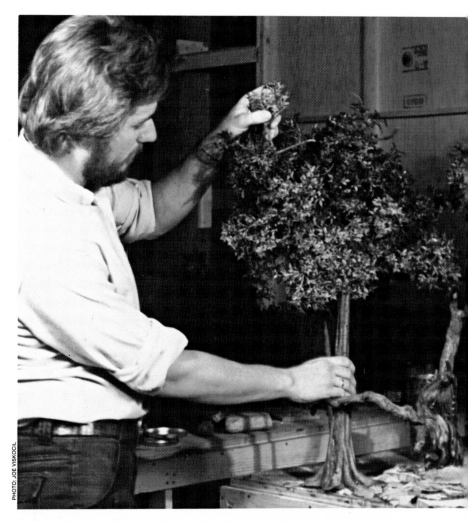

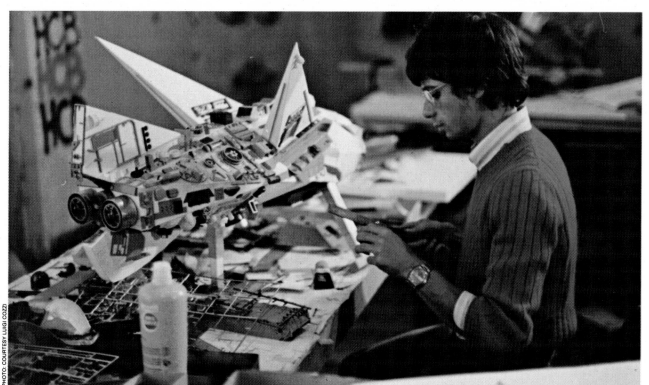

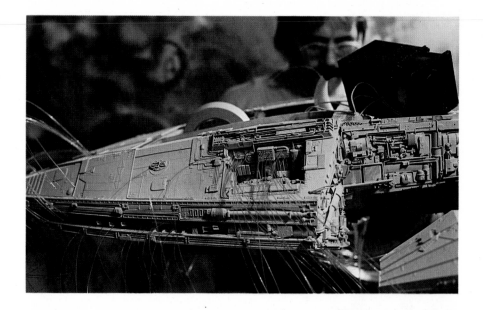

The *Galactica* from ABC's *Battlestar Galactica* series was originally designed by illustrators Ralph McQuarrie and Joe Johnston. Modelmaker Grant McCune supervised the construction. Plywood bulkheads were laid over a steel pipe core to give strength and support to the model which, when completed, weighed about 60 lbs. and was seven feet in length. The frame work was surfaced in sheet acrylic and detailed. Also, the model was rigged with interior illumination—tiny lights that appear over the surface of the craft. This was accomplished by threading the model with 800 strands of fiber optic piping, some of which can be seen in the illustration at the top of this page. A good deal of attention was paid to the landing bays at the rear of the craft. Detailed interior work with a sub-miniature perspective painting placed a short way into the opening of the docking bay give the illusions of being able to see a long distance into the bay. Additionally, sequencing landing lights were rigged, able to sequence with the Dykstraflex camera frame by frame. This remarkable shot is seen in the opening title shots of each episode.

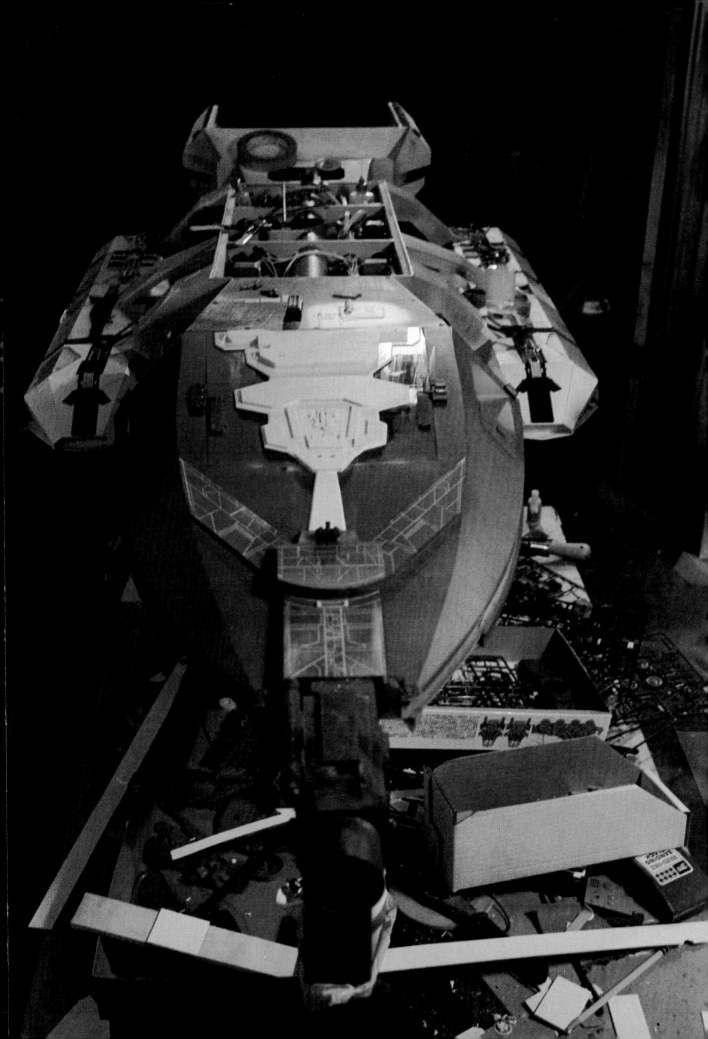

J ack Webb's TV series, *Project UFO*, needed new flying saucers of every shape and description each week. The saucer factory was set up at Brick Price Movie Miniatures. Interestingly, these saucers were based on reported sightings as documented by the Air Force's *Project Bluebook*. The UFO shown under construction in this series of photos proves that not all models are miniature or that not all miniatures are small. This one required five people to load it into the truck that transported it to the studio for filming. This particular model weighed in at 800 lbs, was eight feet wide and 15 feet long. It took six days to construct from scratch. In this specific instance the UFO sighting was a hoax—the ship had to look like it was made in somebody's backyard. It was designed to be flown hanging from a cable underneath a helicopter. The Federal Aviation Authority, however, refused to grant permission for the flight, even though the model had been designed without any "lifting" surfaces to insure stability. The shape had been borrowed from series consultant Col. Coleman's illustrations of lifting bodies designed for the Air Force. Finally, a miniature of the craft had to be built and filmed in front projection to get around the FAA's ban. The large craft was built of plywood and covered with aluminum tape. The tape was smoothed and polished to mirror sleekness—glistening in seamless beauty.

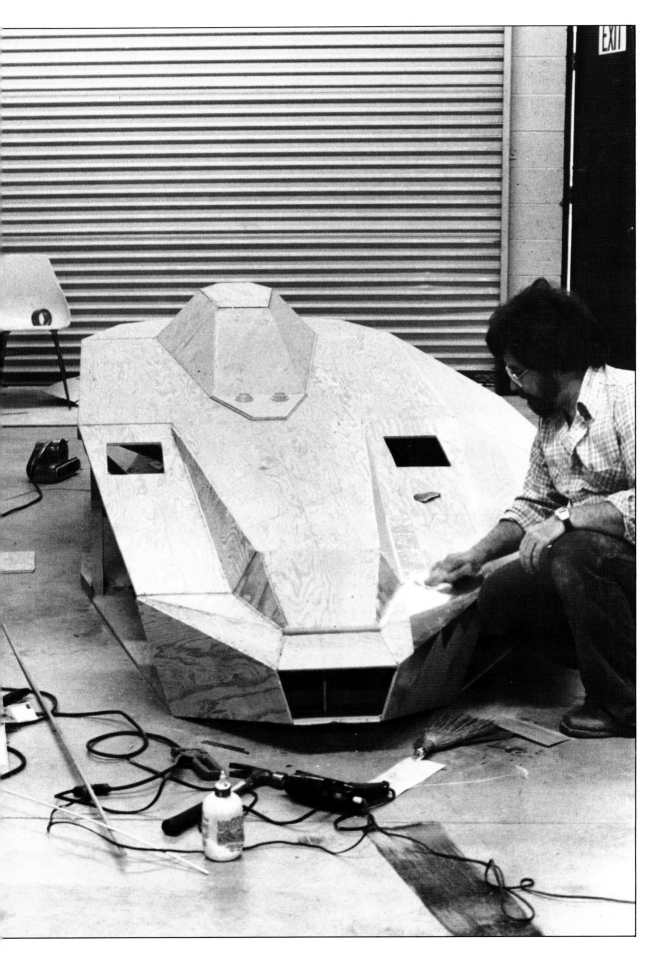

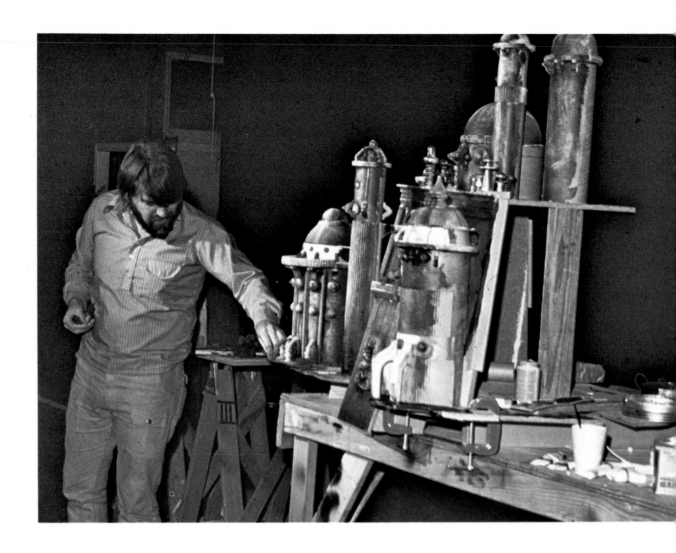

The castle **(above)** from *Flesh Gordon*, built by Tom Scherman. Mike Minor, who was serving as art director on the famous underground fantasy, had to leave in the midst of production to work on a film entitled *Jamaica Reef*. He left a rough sketch of the castle to get Scherman started. Scherman re-worked the design keeping in mind the shapes at the Griffith Observatory. Here it stands in mid-construction at the *Flesh Gordon* model shop. The cylindrical design was built up from a base of cardboard mailing tubes and detailed with pieces of corrugated cardboard. The corbel and balustrades were built from picture frame molding. Plastic bowls and wood turnings filled out the rest of the structure. Across from the studio was a shop that sold plastic decoupage materials which served to work the moldings around corners, etc.

Greg Jein and Tom Scherman **(upper right)** were responsible for most of the intricate model work that went into *Flesh Gordon*. Here we see Jein and Scherman at work in the studio adding finishing touches to the "Ladybug" vehicles and an insect creature that served as one of the castle tower ornaments.

Battlestar Galactica **(right)** made use of the talented artists and equipment that had contributed to the success of *Star Wars*. One of the Cylon Basestars is seen in a very early stage of construction. The design of the Basestar went through five different artists and designers; none of the designs seemed exactly right. Finally, Grant McCune reworked the concepts into the double wheel design that is now familiar to TV viewers of the series. The Basestar model is about four feet in diameter, built on a base of acrylic plastic. When possible, McCune prefers to work with acrylic, as the glued plastic to plastic bond is very strong. The model is a study in bilateral symmetry, with each side having five different surface sections. The wheel surfaces are built back to back to form a single wheel. Finally the complete Basestar consists of the two wheels connected together through a center column.

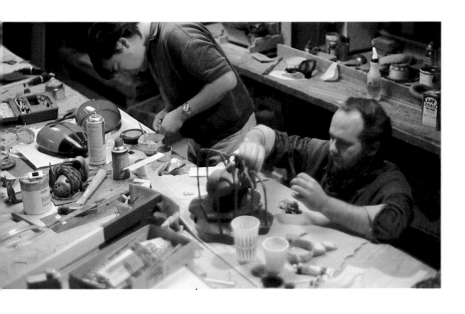

The miniature version of the *Lost Saucer* slowly descends into its table-top forest set for the opening credits sequence of the Sid and Marty Krofft television series. The model was an accurate duplication of the full-scale, live-action set, which, of course, doesn't fly. The forest set was built by Mike Minor and Joe Viskocil. The saucer is slowly lowered, attached from the rear to a boom arm. The boom, support arm and even the electrical cables that supply power to the ring of flashing lights at the base of the saucer are all painted the same shade of blue. This blue background will be removed electronically by a process called "chroma-key."

Another background is inserted in the blue areas that have been removed by the chroma-key. Television and video tape have an advantage over the film medium in that special effects, such as split screen and traveling mattes, can be performed at the press of a few buttons and viewed instantly. The same process on film requires weeks of tests and special printing. Film, however, has much greater resolution, and can be viewed on giant theater screens in multi-channel stereo. Eventually, though, research will wed the electronic swiftness of television with the visual acuity of film into one "super medium."

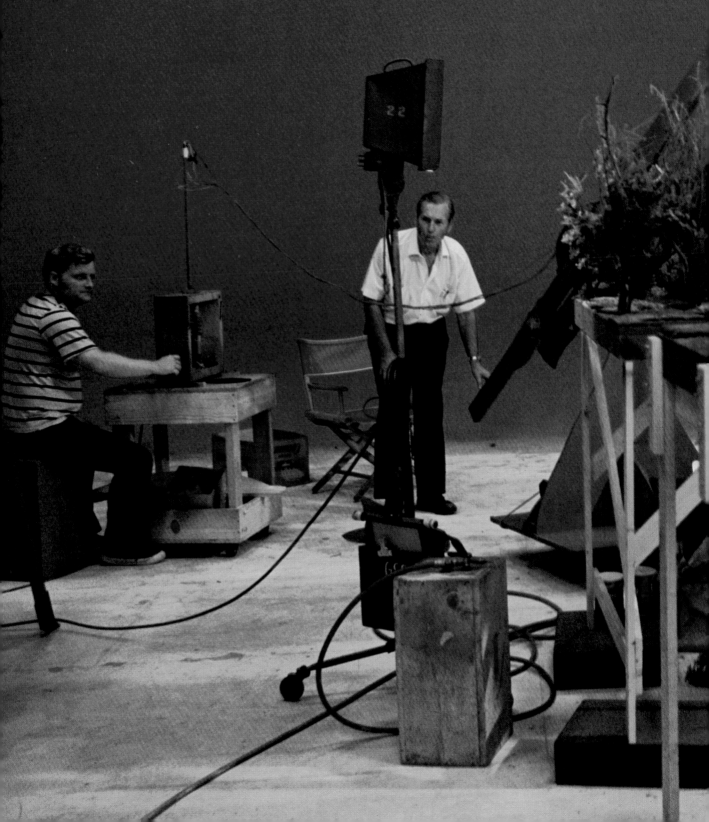

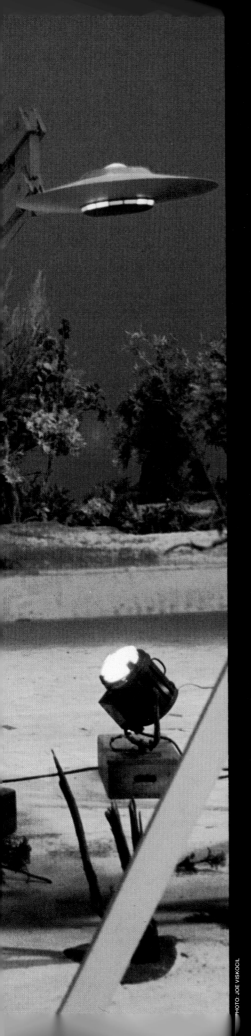

The Ships

The shapes of ships in science fiction and fantasy have changed and evolved over the years. In recent times, NASA space exploration and design have had a profound influence on the spaceships created for the cinema. The ships from the 30s, thought so futuristic, are now antiques. As technology moves, so do the visions of designers. In the 30s, designers had to imagine what spaceships might look like, if it were possible for men to travel to the Moon. Today we know what they look like and designers are striving to imagine what refinements or even totally new concepts might be possible with some technological revolution just around the corner or even hundreds of years from now. One of the most unbounded areas of design comes under the heading of alien craft. What does the technological hardware of a race millions of years ahead of us on the evolutionary scale look like? Suppose they are beings not even remotely like us—classic bug-eyed monsters with thousands of hairy tentacles, or life based on something besides carbon. . . silicon, for instance? This chapter will look at some of the hundreds of ships both above the air and under the sea.

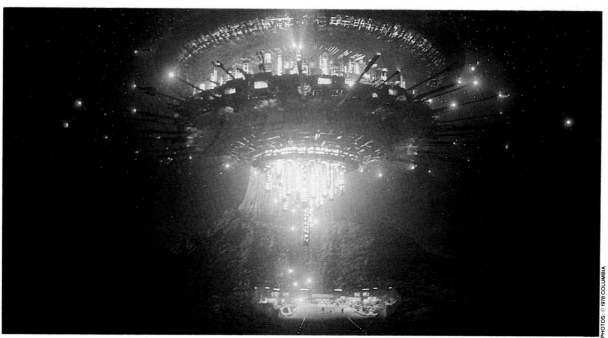

24

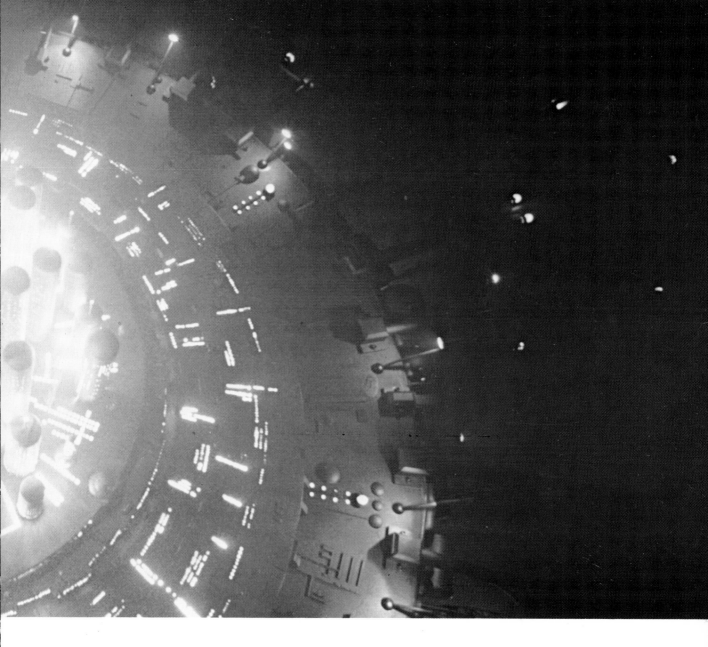

The first lady of spaceships—the Mothership from Steven Spielberg's *Close Encounters of the Third Kind*. It was not until very late in the production that the concept for the design of the Mothership was finalized. While Spielberg was filming the India sequence, he passed an oil refinery at night illuminated by hundreds small light bulbs. Back at Future General, Doug Trumbull and Steven Spielberg sat down with illustrator George Jensen. A number of renderings were done, but still Spielberg wasn't satisfied. Then one night while driving on Mulholland Drive, Spielberg looked at a view of the San Fernando Valley lit up at night. This vision and Doug Trumbull's suggestions for a "City of Light" were melded together by artist Ralph McQuarrie, who ultimately painted what would become the Mothership. Then chief modelmaker Greg Jein sculpted out the tiers approximating the art layer for layer. He was assisted by Peter Anderson, Larry Albright, Jim Dow and Ken Swenson. Dimensional artist Larry Albright created the incredible network of neon tubing that would generate most of the glow that would give meaning to the name City of Light. Bob Shepherd, production manager for *Star Wars*, organized the complex maze of electrical systems. Mothership photography was ably handled by the very talented Dennis Muren, assisted by Scott Squires. Muren was responsible for many of the memorable model flight sequences in *Star Wars* and *Battlestar Galactica*, as well as the *Star Wars* sequel, *The Empire Strikes Back*.

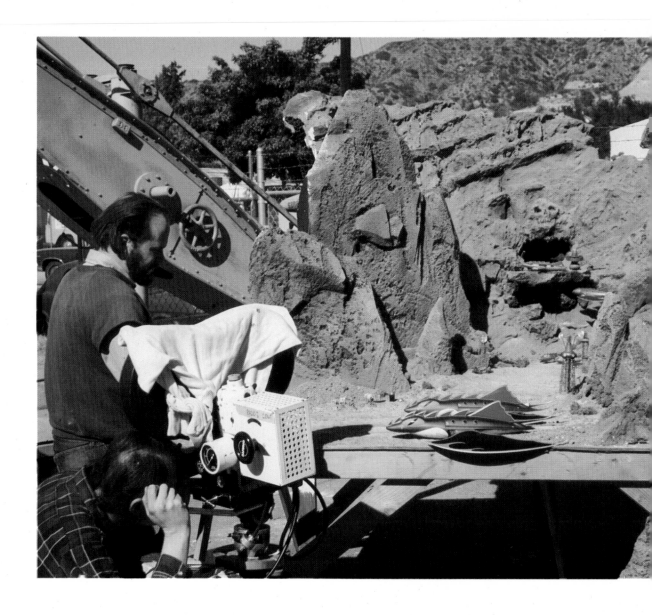

Emperor Whang's fortress from *Flesh Gordon* **(above)** was the creation of model maker Tom Scherman. Scherman is pictured at the left with cinematographer Dennis Muren behind the camera. Greg Jein's half-scale ships are in the background. The mixture of scales with the larger ships in the foreground "forces" the perspective of the shot—the miniature set will appear to the camera to be deeper than it would otherwise. The cliffs are carved and painted styrofoam that has been textured to resemble rough rock by spraying and splattering the styrofoam with acetone, which partially dissolves the plastic, pitting the surface.

Gene Warren **(upper right)** has had a hand in Hollywood special effects since the 50s. Effects for such films as *Wonderful World of the Brothers Grimm* to *The Time Machine* to TV's *Land of the Lost* have been produced under his direction. Here he positions one of the model TV cameras on the "Cetecean," built for NBC's *Man From Atlantis.* The underwater sequences with the sub were filmed "dry," the murky water was an optical effect.

The cave and underwater cliffs were built by the remarkable Mike Minor, who constructed the rough slopes out of aluminum foil. The crumpled foil gives just the right texture for the rock walls, which were then painted.

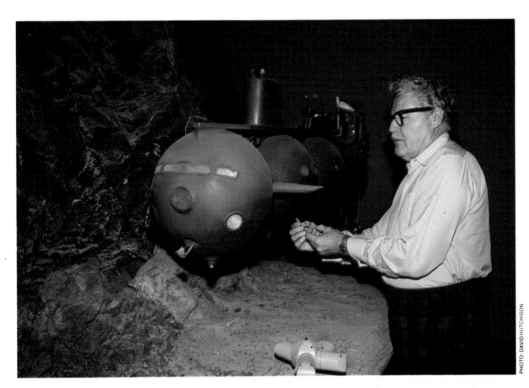

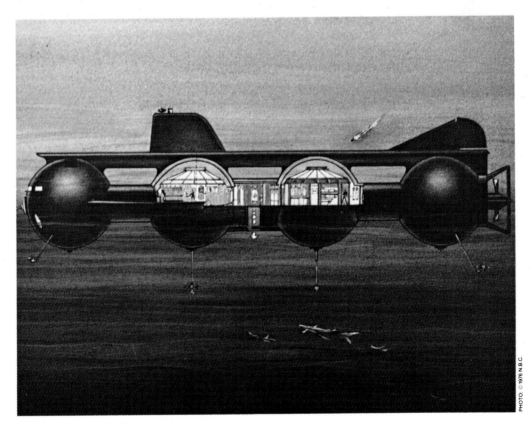

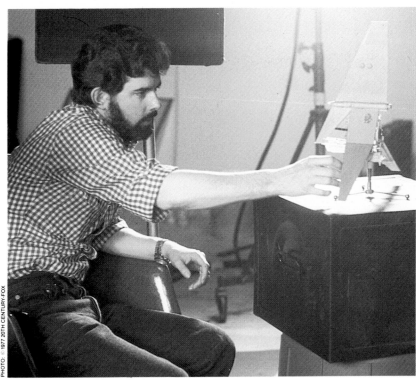

G eorge Lucas (**above**), creator of *Star Wars*, reaches out to touch Luke Skywalker's T-16 Skyhopper. Even before his *American Grafitti* was brought to the screen, Lucas had the idea for a space fantasy adventure—*The Adventures of Luke Skywalker*. He had tried many times to gain the interest of Hollywood's studio executives, but was told that science-fiction films didn't make money. *2001* made $19,000,000, but that was the most that could be expected. Finally, 20th Century-Fox was persuaded to gamble on Lucas' vision. Since that time, of course, *Star Wars* has made world-wide box-office history and opened the science-fiction floodgates. Now those same studio executives that had turned thumbs down on the science-fiction film are investing millions of dollars in new equipment and techniques. The wild flight of imagination that the genre encourages means that whole new technologies in filmmaking must be developed. The sophisticated computer-controlled camera systems that had been in the back of the mind of many of Hollywood's special-effects artists and were finally built for *Star Wars* are becoming standard equipment everywhere. Incidentally, the T-16 Skyhopper pictured above was seen only briefly in *Star Wars* as a model in the hands of Luke Skywalker. It was designed by Joe Johnston as Luke's "sportscar"—a low orbital spacecraft used for "short hops" and fun trips. Luke says near the end of the film that he "used to bull's-eye 'womp-rats' in my T-16 back home."

P aul Gentry (**left**) photographs one of two spaceships designed and built by Dave Carson for *The Vortex*. A number of passes through the camera will be required to properly record the sequence. One of the passes will expose just the tiny lights built into the model. A fog filter will be placed on the front the camera to make the ship's lights hazy—this will make them appear as if they had been photographed from a distance through atmospheric haze. Such touches as this will lend a greater look of reality to the model shot, helping achieve that real-life, full-scale look.

29

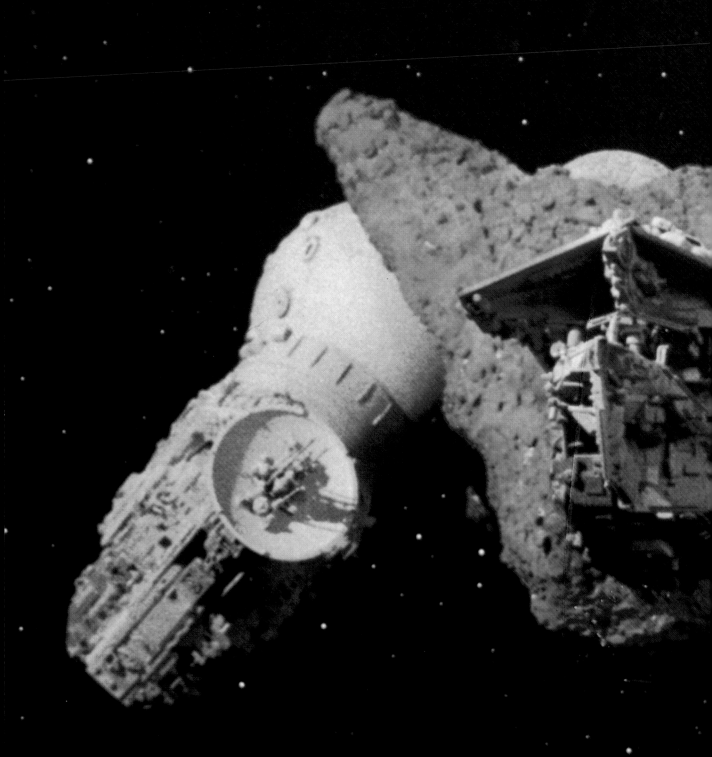

The immense Dragonship dwarfs the Starfire in this clip from Filmation's Saturday morning space adventure series *Jason of Star Command*. The series is unusual for the sheer quantity of special-effects sequences produced for each short weekly episode. An adventure series on Saturday morning TV is very difficult to produce with the severe budgetary restrictions and strict censorship codes. However, the series is filled with model animation, laser effects, traveling matte sequences of ships crossing planets, starfields, etc.

The Filmation effects unit make use of computer-controlled cameras—a system which is becoming very widespread since the advent of *Star Wars*. They can produce their own traveling mattes in the camera, all within the space of a day. The essence of the system lies in the capability of the camera to repeat

moves exactly. For example, on the first pass, a hold-back matte is produced by loading the camera with a black-and-white negative and photographing the model against a black background. The model is overexposed so that it appears as a solid black image against a clear field. This piece of film will serve as the traveling matte or mask. A second pass through the camera exposes the model properly on color negative stock. The black-and-white negative is processed in-house and then, when dry, bi-packed with the exposed, but undeveloped, color negative of the model. The black-and-white mask is placed on top of the color negative and run through the camera while exposing the film to a star field. In this way, the stars are recorded only on the background and not on top of the image of the model, since the black image of the model on the black-

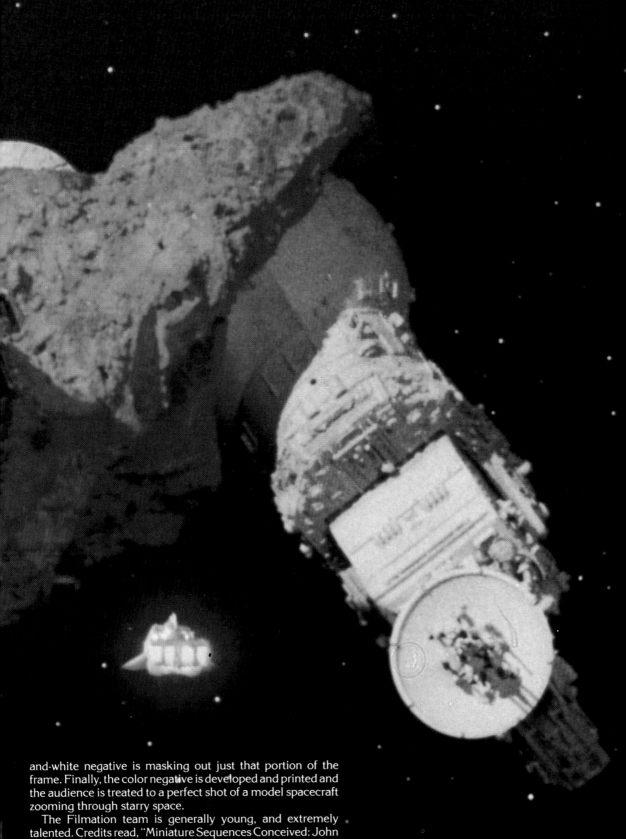

and-white negative is masking out just that portion of the frame. Finally, the color negative is developed and printed and the audience is treated to a perfect shot of a model spacecraft zooming through starry space.

The Filmation team is generally young, and extremely talented. Credits read, "Miniature Sequences Conceived: John Grusd, Paul Huston, Ease Owyeung; Miniature Photography: Jim Veilleux and Diana Wooten; Stop-Motion Animation: James Aupperle and Stephen Czerkas."

Two episodes have made extensive use of model animation. "There are over 40 animation cuts in two segments of *Jason*," explains James Aupperle, "which is as much as a feature movie might have."

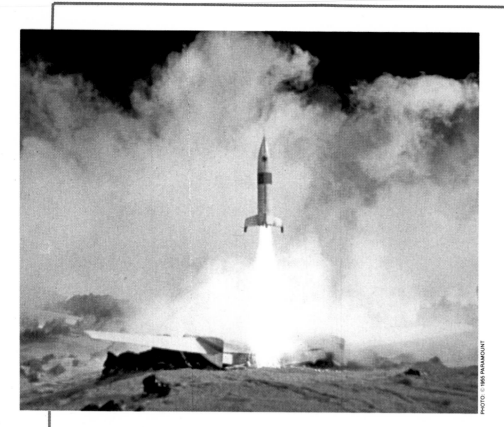

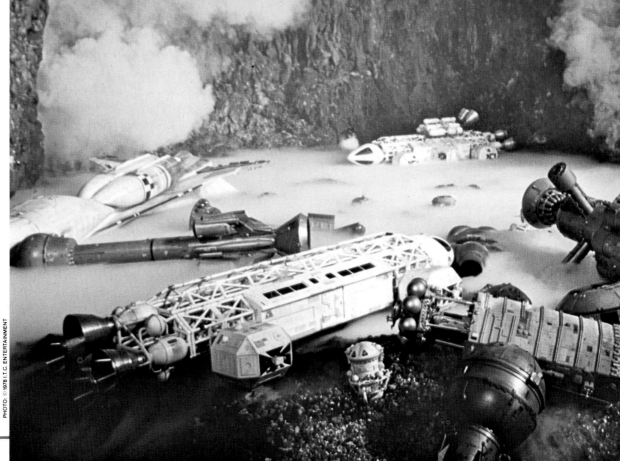

32

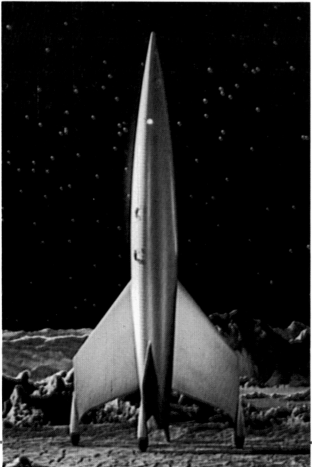

George Pal's *Conquest of Space* (**upper left**) united the talents of special-effects artists John P. Fulton, Irmin Roberts, Paul Lerpae, Ivyl Burks and Jan Domela. The Martian landing rocket, looking like a gigantic flying wing with round appendages, flew horizontally and landed in the same manner. The return trip was made via a piggyback rocket that rose vertically from the mothership's back.

Flight to Mars (**upper right**) was shot in just 11 days, with special effects by Jack Rabin and Irving Block. This single-stage rocket evokes the era of its design by resting solely on its tailfins. Rabin and Block, as a team, produced effects for many of the "B" thriller SF adventures in the 50s. Though Block is now in semiretirement, Jack Rabin still produces special-effects opticals in his Hollywood studio.

Space: 1999 (**lower left**) reflects the era in spacecraft design. Brian Johnson, the designer, follows the modern trend toward framework construction—ships that do not have to make any concession to aerodynamic sleekness. The famous "Eagles," however, had sleek, detachable nosecones for emergency landings on planets.

Destination Moon (**lower right**), George Pal's production of a Robert Heinlein screenplay. Heinlein also oversaw the design of the single-stage, atomic-powered rocket. Mechanical effects were by Lee Zavitz, with model photography by John Abbott. The astronauts seen climbing down the ladder of the ship are actually fine animation, frame by frame.

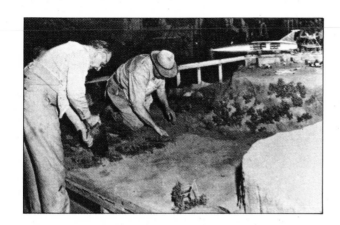

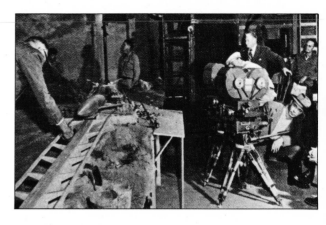

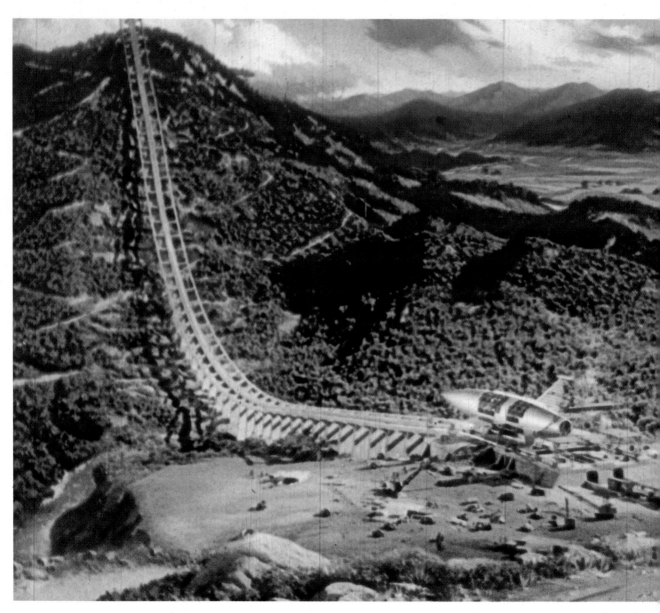

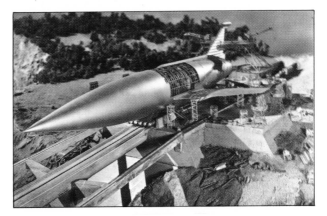

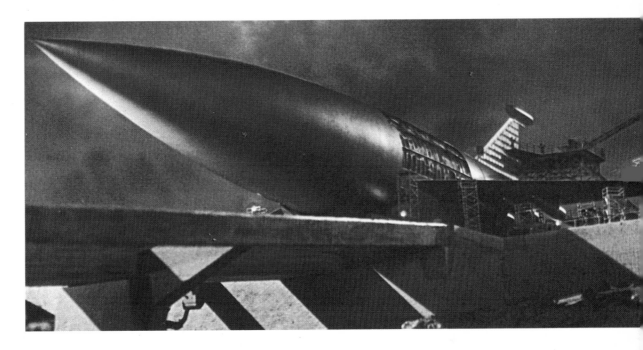

Released in 1951, *When Worlds Collide* was produced at a cost of $963,000. George Pal gathered together the talents of special-effects artist Gordon Jennings, fine artist Chelsey Bonestell and art directors Hal Pereira and Albert Nozaki. Gordon Jennings and his team at Paramount received an Academy Award for their stunning miniatures and model work. A carpenter **(above left)** saws his way through part of the miniature stage to make room for the three-strip Technicolor camera to film closeups of the rocket base. Twin cameras **(above left)** record an earthquake sequence as one of the technicians gently rocks the support base. The Ark **(above)** blasts its way along the ramp. The Ark in mid-construction **(above right and color)**, showing the network of ribs that were built inside the model for the early sequences of the film. Panels covered the exposed ribs when the later sequences were filmed. One of the complete composites **(color, left)** shows the rocket on its ramp surrounded by tiny models of construction equipment. The sky and most of the rolling hills are actually a Bonestell painting.

Miniature Worlds in the Making

The Brothers Hildebrandt are perhaps best known for their fantasy paintings illustrating key scenes from such epics as *The Lord of the Rings* and *The Hobbit*. As youngsters, however, their time was spent exploring anima-tion and filmmaking. With an inexpensive 8mm movie camera, they filmed sequences of cartoon animation off the TV screen to study the process frame by frame. After seeing Pal's *War of the Worlds*, they built Martian war machines and miniature cities in order to recreate their own 8mm versions of the special-effects magic that had made the fantasy creation

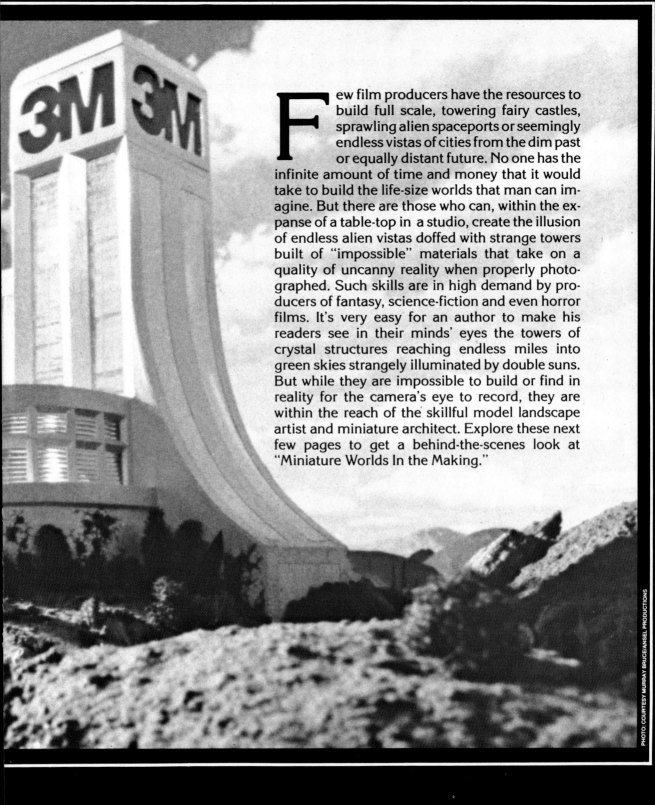

Few film producers have the resources to build full scale, towering fairy castles, sprawling alien spaceports or seemingly endless vistas of cities from the dim past or equally distant future. No one has the infinite amount of time and money that it would take to build the life-size worlds that man can imagine. But there are those who can, within the expanse of a table-top in a studio, create the illusion of endless alien vistas doffed with strange towers built of "impossible" materials that take on a quality of uncanny reality when properly photographed. Such skills are in high demand by producers of fantasy, science-fiction and even horror films. It's very easy for an author to make his readers see in their minds' eyes the towers of crystal structures reaching endless miles into green skies strangely illuminated by double suns. But while they are impossible to build or find in reality for the camera's eye to record, they are within the reach of the skillful model landscape artist and miniature architect. Explore these next few pages to get a behind-the-scenes look at "Miniature Worlds In the Making."

of Pal's classic film seem so real.

Recently, the Hildebrandts have returned to their first love—fantasy film. They are tooling up for a film project of their own devising, working in the seclusion of a suburban studio. They were drawn away briefly when commissioned to

build a miniature world for a 3M Company commercial. The Hildebrandt skies and landscapes come alive in the dimensional miniatures, with sunny hills and clear horizons providing a majestic setting for the 3M tower. Assisting in the miniature construction was Disney veteran Gene Leroy,

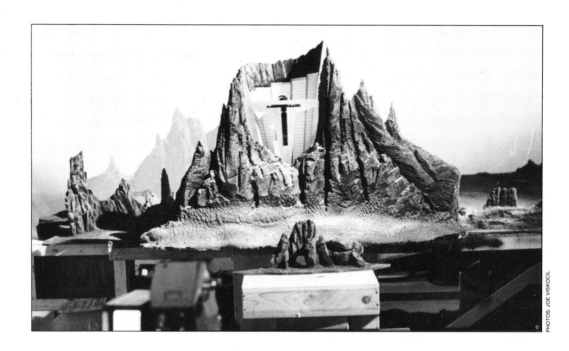

PHOTOS: JOE VISKOCIL

Production schedules for weekly television series are normally very tight. Realistic dramas can draw upon vast stocks of scenery and props; not so with imaginative SF and fantasy productions. Frequently, shows that are owned by the same producer will borrow bits and pieces from each other and try to redress them, very often successfully. The picture above shows the mountain crater set used in Krofft's *Far Out Space Nuts*. The front "T" unit was a walkway-bridge across the crags of the crater-like mountain. Mike Minor redressed his set for the Krofft production of *Lost Saucer*. These two shows were produced almost simultaneously, which kept Minor and his crew moving quickly from set to set, making use of miniature pieces many times. Often sets were cannibalized only minutes after the cameras had finished shooting; the parts were ingeniously reassembled into new configurations. The issue here is not so much one of economy, but the lack of time to build each set from scratch. Imaginative craftsmanship kept each setup looking fresh and unique.

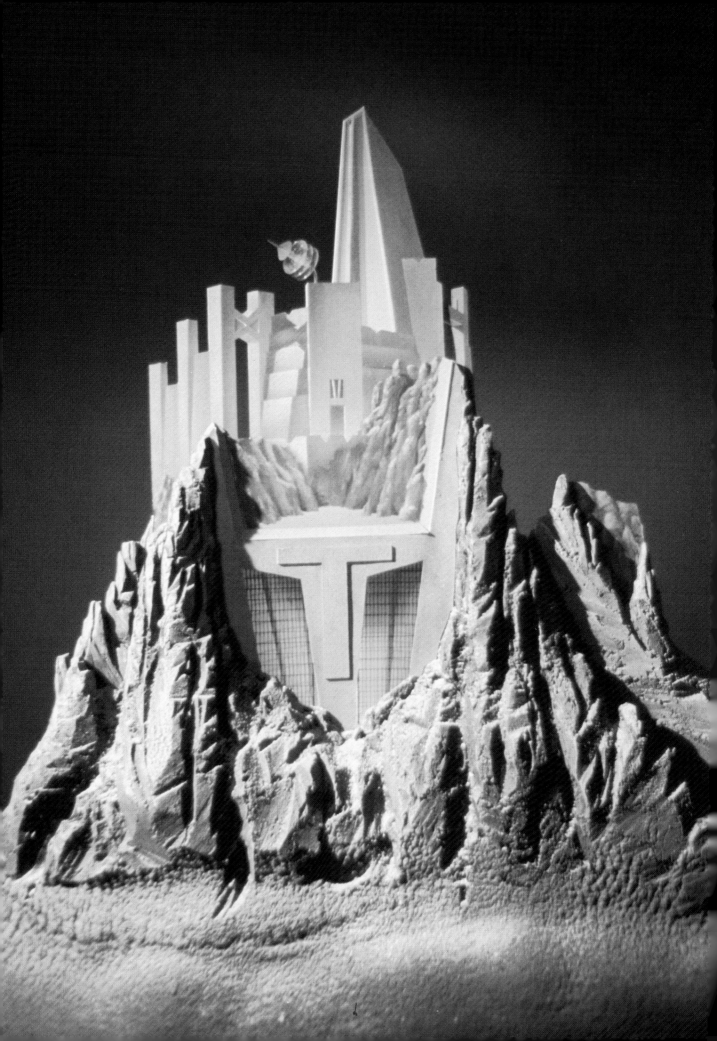

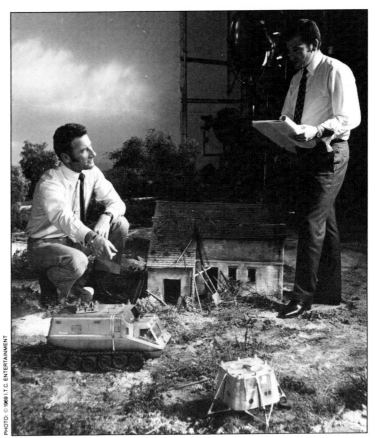

Derek Meddings (**above**) is on the miniature land-scape set used in the *UFO* episode entitled "The Long Sleep." The SHADO vehicle is parked outside a run-down farmhouse. Meddings cannibalized other models from old shows and commercial model kits to produce model vehicles that were remote controlled. Here the SHADO vehicle had been in search of the lower half of a craft called the Spacedumper, which is to the right of the photo. This series was made at the Century 21 Studios in Slough, England, also the home of many Gerry Anderson puppet shows.

The Phoenix spacecraft (**left**) from *Doppelganger* or *Journey to the Far Side of the Sun* sits on its pad at Eurosec. Another of Derek Meddings-superbly designed and engineered models seems as live and poised for flight as any NASA spacecraft. The true size of the model can only be discerned if you know that the automobiles parked behind the rocket in the background are actually "match box" toys from the hobby shop. Meddings has pursued reality to such an extent here that tire tread marks are visible in scale on the roadway and parking lot surface.

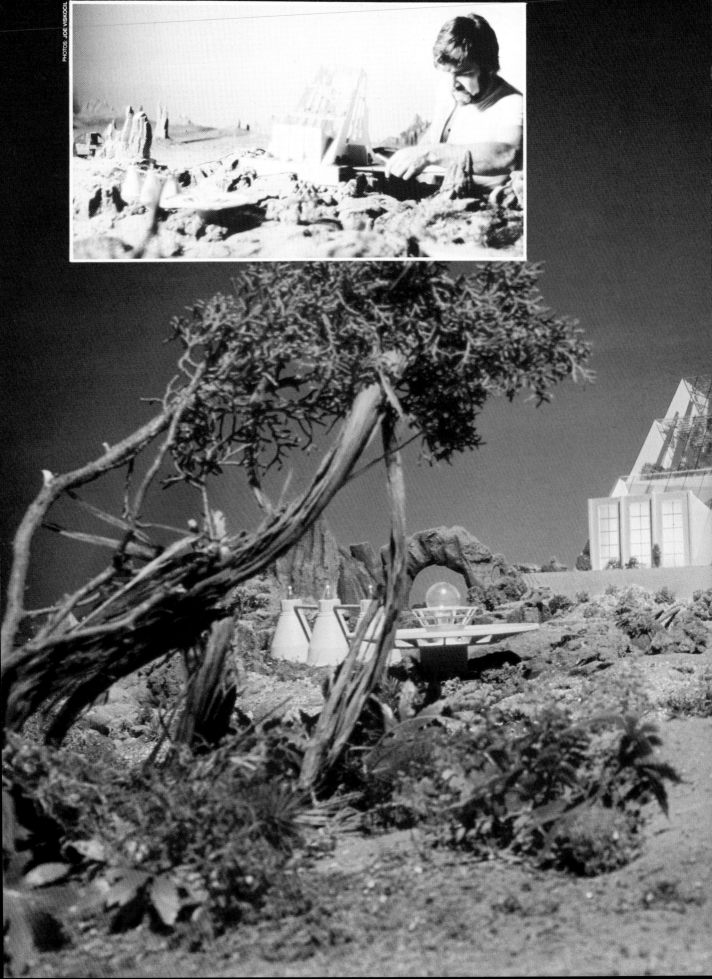

S id and Marty Krofft's *Far Out Space Nuts* required an enormous quantity of table-top miniature worlds. Mike Minor, assisted by Joe Viskocil, turned out quality landscapes with architecturally interesting buildings practically over night. Minor had to produce sets for two shows a week. This particular world was built in two days. Of course, the secret to such speed lies in the ability to make use of parts from last week's sets—repainted, modified and photographed from a different angle. It also helps to be able to assemble sets from easily obtainable materials that can be used in some entirely new fashion, with little alteration. The conical structures at left, for example, were plastic coffee cups before being repainted, turned upside down and combined with other elements. It takes a special kind of eye to be able to walk through a toy shop or hobby store and find ordinary manufactured shapes and then recombine them into a believable structure. Other structures must be built practically from scratch, such as Minor's intriguing illuminated glass house assembled from clear plastic and cardboard. Sharp crags carved by hand to mimic the erosion of wind and rain dot the landscape dressed with plastic foliage. Plastic foliage is available in a wonderful array of sizes and shapes that will survive under the intense heat and bright light that is often necessary for model photography. Inset shows artist Mike Minor at work.

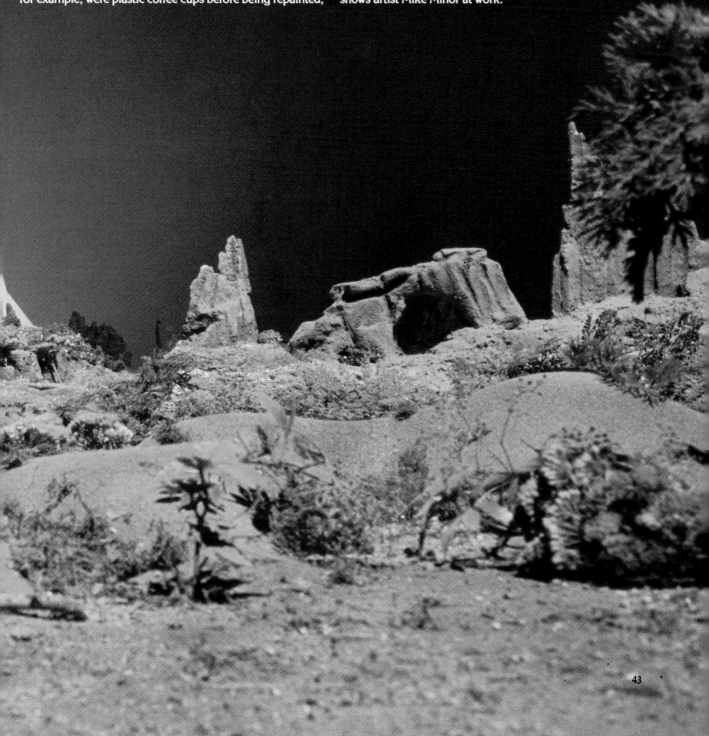

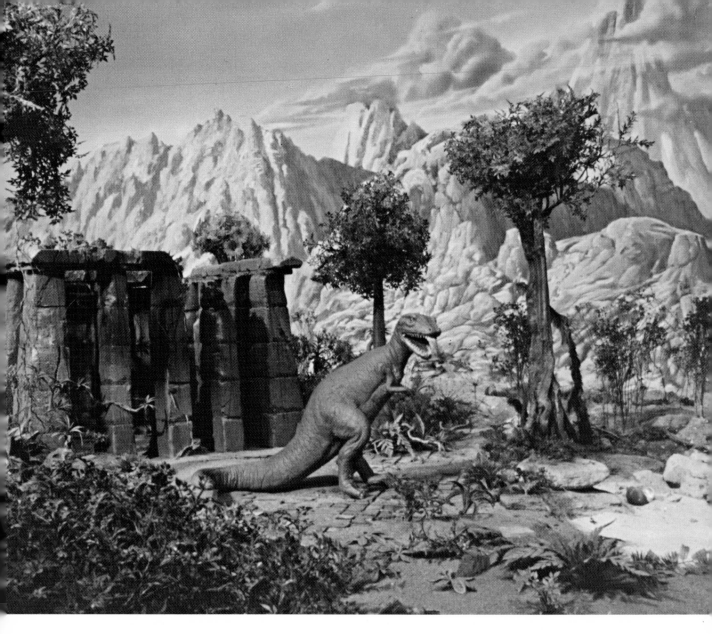

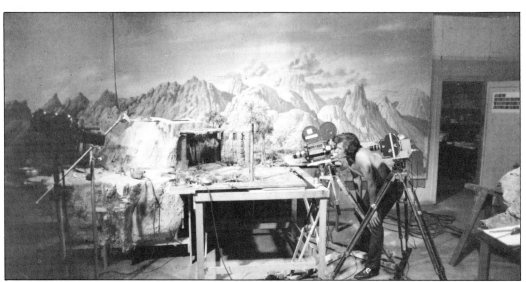

P rehistoric worlds **(left)** have always been fair game for table-top setups. Gigantism is usually the basic theme—gigantic mountains and cliffs, gigantic plants, ferns and trees and, of course, gigantic dinosaurs. All this gigantism, however, would eat up a gigantic amount of dollars if full-scale sets were attempted. These sets were assembled at Gene Warren's studio for the TV series *Land of the Lost*. The towering cliffs from eons-gone-by were by Mike Minor. At lower left is a wider view showing Gene Waren Jr. lining up a shot on the set.

Major Mars' secret mountain hideaway **(below)** was created by Tom Scherman. Built for *The Further Adventures of Major Mars*, it uses a model of the Griffith Observatory, but never the real location. The film is so fantasy-oriented that almost every exterior shot had to be built in miniature. This set includes some wonderful touches of fantasy; the era is evoked by the use of a model 1949 Nash parked next to the rustic guard hut that even has an old wagon wheel leaning against the door. The roadway, which winds its way (two miles according to the sign) up the mountain to the secret headquarters, is built in forced perspective to give the set more depth. Time was taken to add tire tread marks to the roadway. The fence at right is a good example of adapting commonly available materials to suit scaled down effects. The chain link fence is plastic screening commonly used for auto body repair. The trees were cannibalized from a "Hungry Jack" commercial produced at Cascade. Good minature landscapes can increase production values enormously.

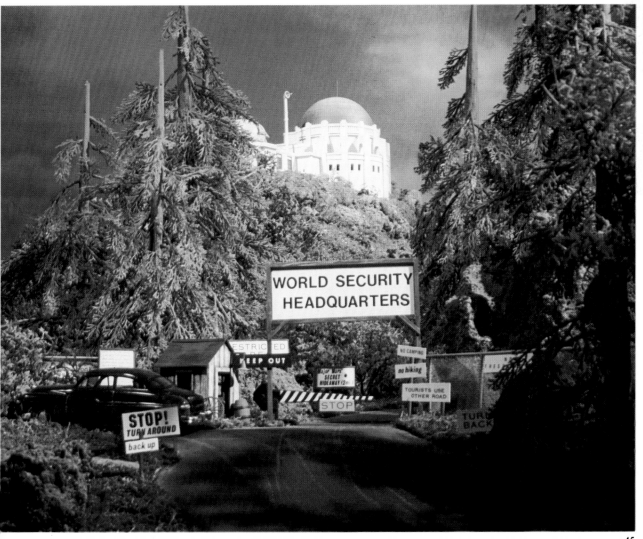

Tom Scherman (**below**) trims the balance on a tower that comprises a section of just one of the many miniature sets built for the classic underground film *Flesh Gordon. Flesh Gordon* climaxes with the destruction of the Emperor Whang's domain; the job of constructing the castle and environs fell largely to Tom Scherman. Greg Jein assisted in many areas of model construction—from sets to model craft. The castle miniatures were constructed from styrofoam and balsa wood and rice paper. The styrofoam was brushed and sprayed with solvent to bring out the required dimensional texture. In the illustration at right you can also see pieces of laboratory equipment used as glass towers, patterned moldings, parts from plastic kits and small toys; all melded into a structure that ultimately had to blend with the color and design of the Griffith Observatory in Los Angeles, which was used as a location for many of the exterior shots. Many of the fanciful miniature sets met a fiery death at the hands of miniature explosion artist Joe Viskocil.

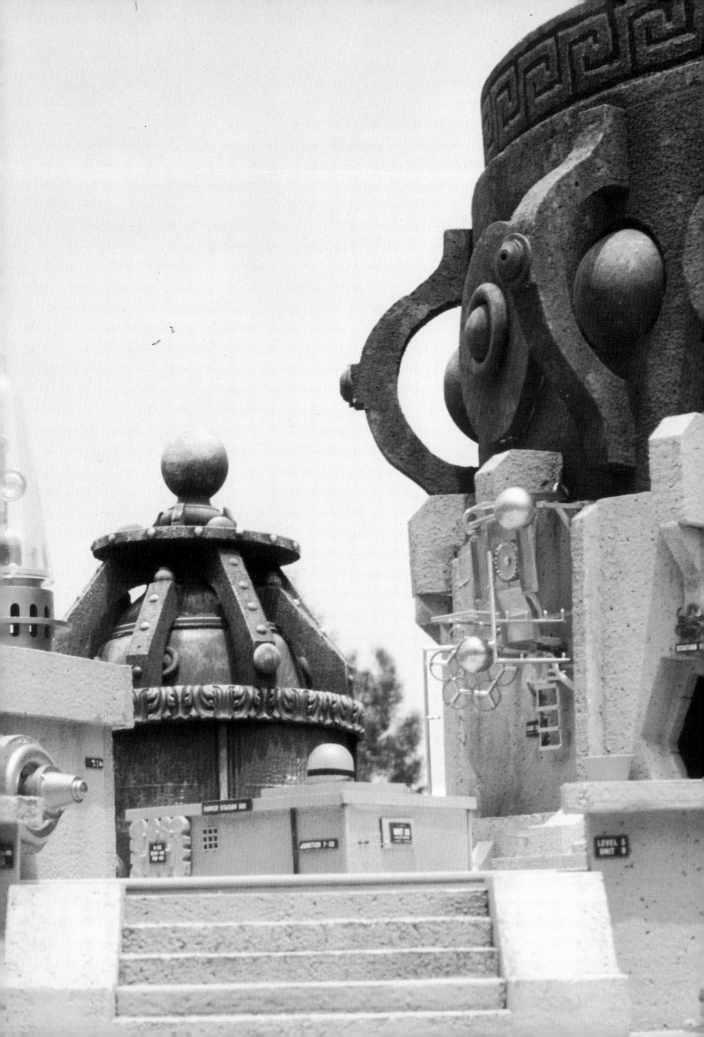

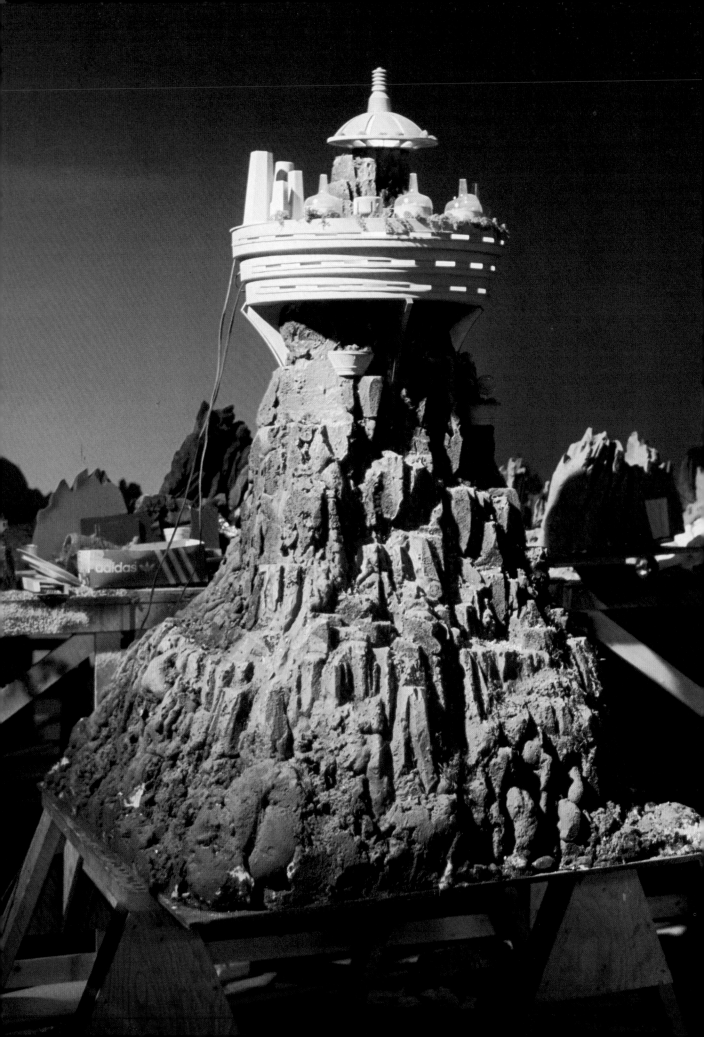

M ike Minor's mountainous miniature for one of the episodes of
Krofft's *Far Out Space Nuts*. Carved and painted styrofoam makes
up the base, while the palatial structure at top is a creative assem-
blage of mostly stock plastic forms. The imaginative use of some upside down
champagne glasses adds to the glistening high-technology look of the struc-
ture. The mountain is dotted with small balconies of plants and capped with a
splendid "penthouse" apartment. The wider view below shows the surround-
ing studio and television cameras giving a clue to the scale of construction.
Sets for the series had to be imagined, built and completed within the shock-
ingly short space of two days.

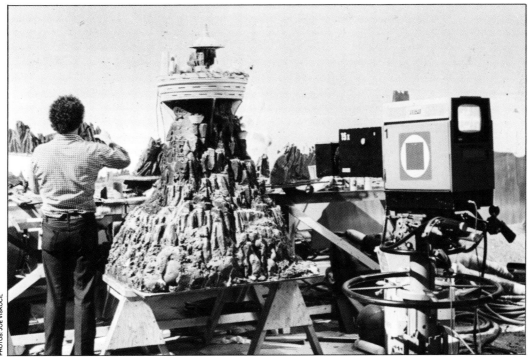

Miniature Effects

I t is one thing to build an accurate reproduction of some airplane or house in miniature, but a problem of an entirely different sort when that house or airplane must be engulfed in a flood or burst into flames. After all, you can't build miniature flames . . . or can you? The art of miniature effects has progressed more slowly than the rest of film technology, perhaps because films requiring realistic effects in miniature were not that common. The special-effects artist gets his experience by working on films, and with each project his skill and inventiveness increases as newer and more difficult problems are solved. It has only been comparatively recently that special-effects films have been produced at a rate which allows a single artist to develop real technique. Today, we are seeing an explosion of realistic techniques being developed for miniatures.

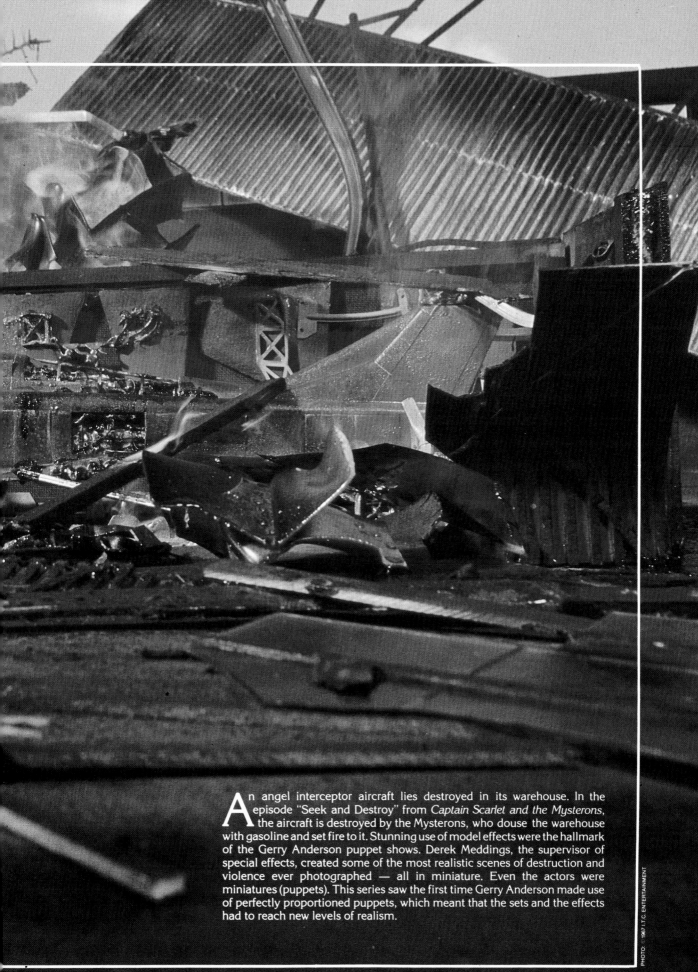

An angel interceptor aircraft lies destroyed in its warehouse. In the episode "Seek and Destroy" from *Captain Scarlet and the Mysterons*, the aircraft is destroyed by the Mysterons, who douse the warehouse with gasoline and set fire to it. Stunning use of model effects were the hallmark of the Gerry Anderson puppet shows. Derek Meddings, the supervisor of special effects, created some of the most realistic scenes of destruction and violence ever photographed — all in miniature. Even the actors were miniatures (puppets). This series saw the first time Gerry Anderson made use of perfectly proportioned puppets, which meant that the sets and the effects had to reach new levels of realism.

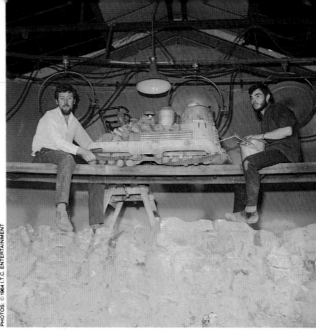

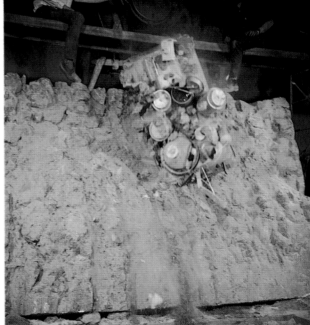

A giant "crab-logging" machine featured prominently in the episode "Path of Destruction" from the Gerry Anderson *Thunderbirds* series. Here from top to bottom are the stages of destruction as the machine topples out of control from the edge of a cliff road. The machine, which is designed to cut paths through dense forest, has two large claws in the front which guide whole trees into its grinders. The sequence was handled by Derek Meddings, supervisor of special effects, and Brian Johnson, director of special effects. Note in the bottom photo the camera in a pit below the level of the stage. The camera must shoot from as low an angle as possible in order to make the miniature appear as large as possible. The logging machine must appear over 10 stories tall. The camera has been protected with padding against falling debris as has the cameraman, who is wearing a hardhat. The camera photographs this sequence at a speed faster than the normal 24 frames per second. When the sequence is projected at normal speed the logging machine will take longer to fall down the model cliff, thereby creating the illusion that it is falling a long distance.

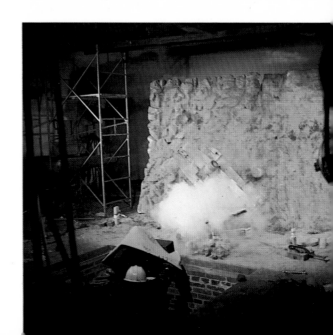

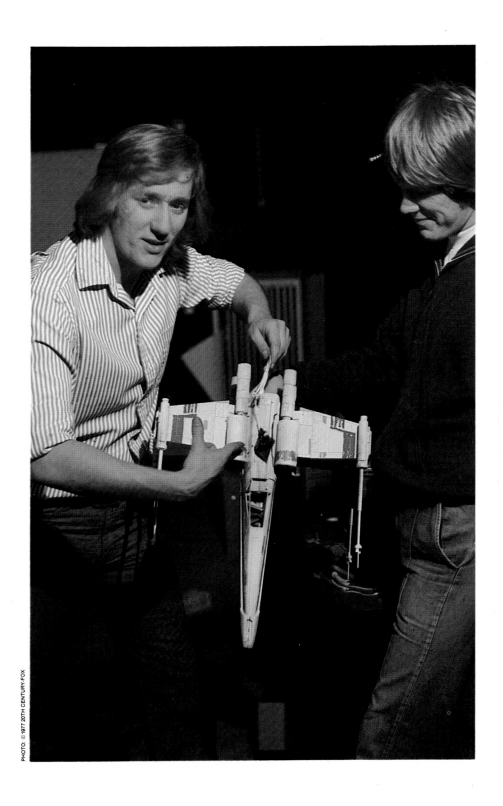

Joe Viskocil demonstrates the proper placement of an explosive charge on an X-wing fighter from *Star Wars*. Joe Johnston, who did much of the re-designing of the fighters from Colin Cantwell's originals, assists. The fighters were carefully scored so the charge would break them apart in a predictable manner. Charges were rigged so that a hit would tear the ship apart along structural members; also, explosions for a given craft should look alike, since they are fueled alike. Such pains taken with the choreography of a miniature explosion and the creation of a firm logic to the look of the effect do much to enhance the reality of the shot.

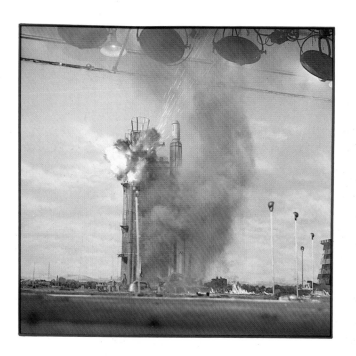

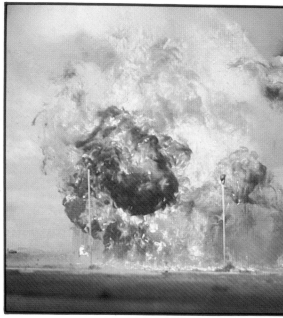

Thunderbirds Are Go (**right**) climaxed with the return to Earth of a manned Martian space probe. The Zero-X plummets Earthward, her main body streaming smoke and flames, cuts a swath of destruction through shops and homes—destroying an entire town before finally blowing itself to bits. The Zero-X took many weeks to build and only two days to destroy. Built at a cost of $2,500, the model weighed 50 lbs. and was about six feet long. Ray Brown was supervising model builder. Derek Meddings, director of special effects, used electronic detonators to set off the cordex explosive, often used by safe breakers. The fireball created to suggest the ignition of hundreds of gallons of fuel was made with naphthalene. Gunpowder, magnesium and napalm were also used at various stages. The last panel shows Meddings with assistants touching up the model for the final explosions.

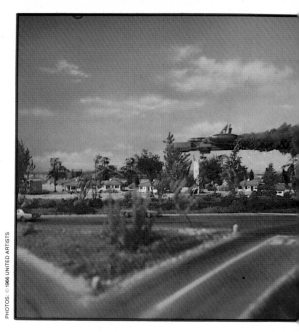

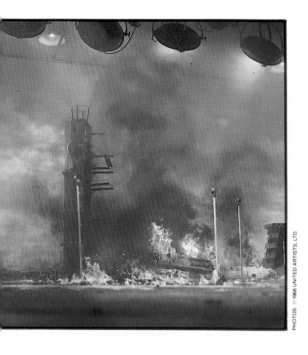

T*hunderbird 6* (**left**) immediately followed *Thunderbirds Are Go*. Derek Meddings again lent his formidable expertise to the miniature effects. The series was becoming famous for its unusual destruction scenes. Often the destruction would follow a series of choreographed jeopardies—one explosion would endanger something else, which would finally explode and that would threaten still another area, and so on. Here a craft, *Skyship One*, crashes onto the top of an Early Warning Tower standing over 1,000 feet above a missile site near Dover. The crew is rescued just as the tower with the Skyship begins to crash. The base below, having been evacuated, the whole mass of wreckage collapses in an eruption of flame. Here, at left, is the stages of destruction produced in miniature of the Dover missile base. The fallen wreckage starts the gantry fire, which erupts spectacularly.

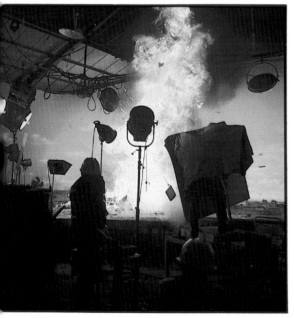

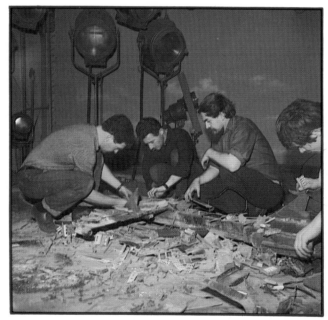

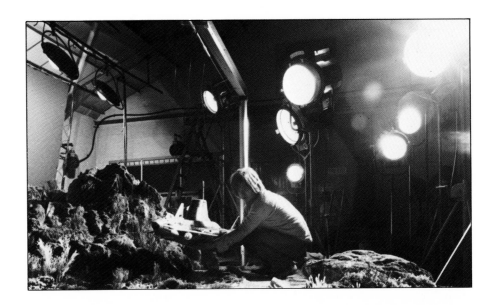

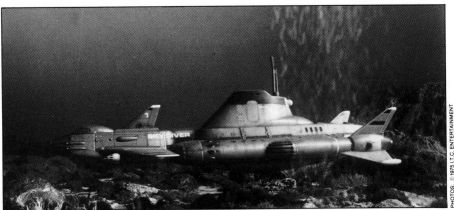

The Skydiver 1 submarine from the British television series *UFO*. This miniature undersea set was built at Century 21 Studios for the series. The model is suspended with clear monofilament line from an aerial brace. The brace operates somewhat like a traverse rod—slowly moving the submarine through the set suspended just above the floor. The submarine is filmed dry, that is on a studio set rather than in a studio tank. The bubble effect, seen in the lower illustration, was achieved by filming the sequence through a small tank place just in front of the camera. Air is pumped through the tank, allowing the bubbles to rise up and making the submarine appear as if it was actually submerged for the sequence. The lens is slightly filtered to create a slight underwater misty effect.

Gerry Anderson's shows are remembered for their imaginative and skillful special effects. This pencil sketch was drawn by Derek Meddings at the time when he was special-effects chief to A-P Films and Century 21 Productions. Special effects productions are usually filled with adventure. Gerry Anderson describes some of the points of interest; fans of his productions will be able to spot others. "I am 'Guv'... note the cigar in the end of the snorkel—I used to smoke Havanas in those days. The mermaid is Sylvia. On Sylvia's left, a caricature of Reg Hill, who was a fanatic about fire regulations. To his left is our dearly beloved cleaner Arthur Cripps—he was at one time an upholsterer and one day made a miniature chair for Lady Penelope. His work was so good he ended up by being property master of the company. Tragically, he died of cancer. The great British Institution—the Tea Wagon—is on the left. The man carrying the outsized cup is our partner and cameraman, John Read. Serving the tea is Iris Ritchens (always popular with the boys, hence the bra as opposed to a skin suit.) On top of the studio is the wreckage of *Fireball XL-5* (not one of its best landings). The flagpole indicates the importance we attach to the American market. Overhead, right, our music director Barry Gray, sitting on a jet-propelled cloud . . . no, the music was not sponsored by Esso. In the immediate foreground left, the boys have put fish in my Jaguar headlamps, and last, but not least, immediate foreground right, Derek Meddings' signature, over which it was always his custom to place his glasses. There are many more items of fun, in the picture, many of them recalling special-effects disasters and some just fun, like Zoony from *Fireball XL-5* abducting Venus."

 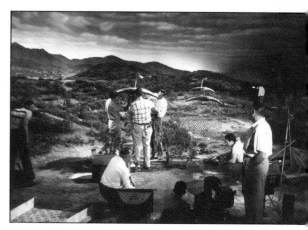

George Pal's *The War of the Worlds*, released in 1953, is a *tour de force* of special effects. Space capsules descend on the Earth from which are born Martian war machines. The aliens unleash a reign of worldwide destruction until succumbing to Earth's bacteria. These pictures detail the set-up from the famous farmhouse sequence. Anne Robinson and Gene Barry have taken refuge in a farm house which just happens to be the impact site for a nest of the Martian machines. One of the cylinders has crashed into the side of the farm house (**right**). The miniature farmhouse set is detailed above. Lee Vasque (**above left**), one of the electricians in Ivyl Burk's prop department which constructed all the miniatures, installs the cobra-head mechanism in one of the suspended war machines on the model set. Each model was suspended with 15 piano wires, some of which carried electrical power to the model. The full miniature set (**above center**) is supervised by the late effects veteran Gordon Jennings, standing at the right. Note the low angle of the three-strip Technicolor camera, with effects cameraman Wallace Kelley kneeling just to the left of the camera. Albert Nozaki designed the unique war machines (**above right**) seen suspended above a smoking crater-pitted miniature field. Each copper-colored war machine measures about 42 inches from tip to tip. Over 200 explosive charges were rigged for this sequence. Walker Hoffman, 81 years old at the time, designed the explosive charges for this sequence as well as the atomic bomb blast later in the picture.

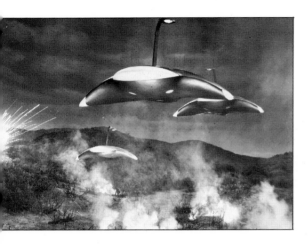

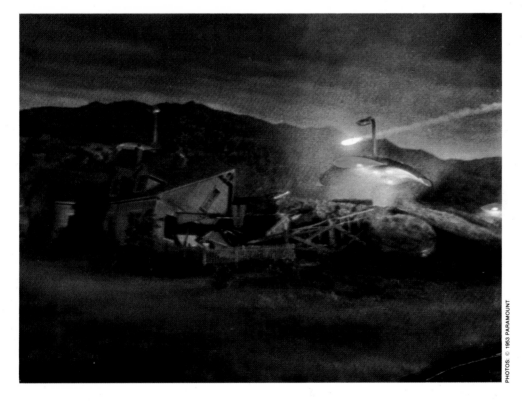

59

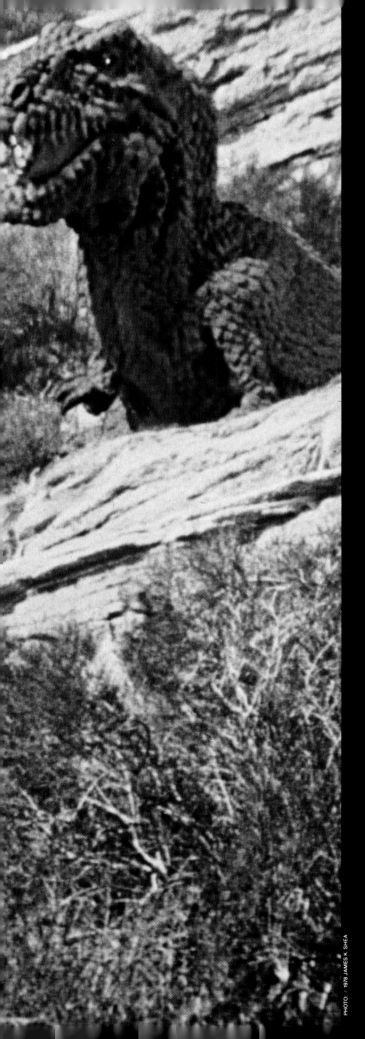

Models For Animation

Constructing life-like creatures in miniature for motion pictures is an art and skill of this century. Each experiment made use of clay models moved a fraction of an inch per frame of film to achieve the illusion of motion, and through motion, life. Though more sophisticated techniques have been developed since then, clay figure animation, or "claymation" as it is sometimes called, is still a source of delight for filmmakers and audiences. Today, when realism is demanded, skeletons are created from ball-and-socket joints. These armatures are hand-machined and can become quite complex and very costly—sometimes as much as $100 an inch.

James Aupperle pokes his head into a scene from *Planet of Dinosaurs* for which he is associate producer. Aupperle's head is in the scene for the same reason the dinosaur is in the scene. A description of the composite matting process is on page 74. In the days of *King Kong*, models were animated on minature sets between levels of scenery painted on glass. Today, the creatures can be made to appear in the midst of a live-action scene—increasing the apparent reality of a sequence. Ray Harryhausen is the undisputed master of this technique.

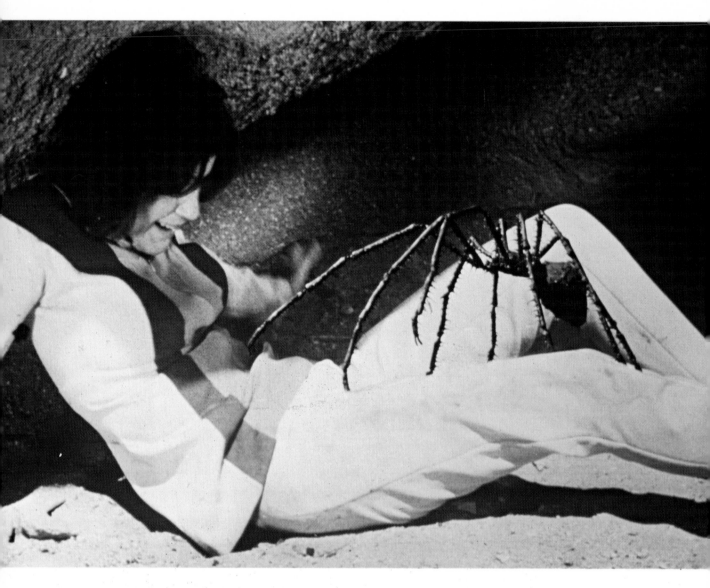

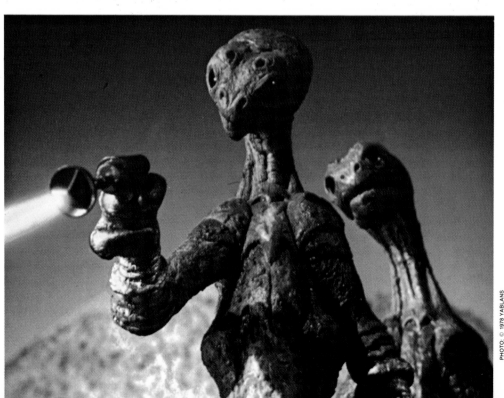

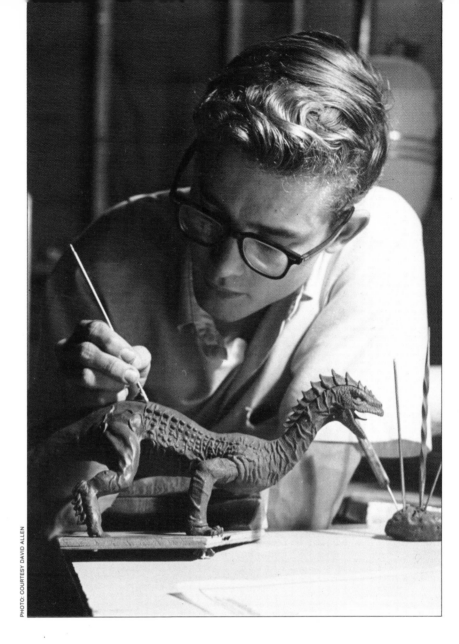

David Allen (**right**), at age 17, sculpts a dragon for a test shot. Since that time he has become well-known for his solo animation of the Chasmasaur in *When Dinosaurs Ruled the Earth*, his work in *Equinox*, the Volkswagen commercial which features a recreated King Kong perched atop the Empire State Building, all filmed in color (he received two Clio nominations for this) and his work in *Flesh Gordon*. About 85% complete is a puppet film entitled *The Magic Treasure* based on *The Selfish Giant* by Oscar Wilde. Two other films, one with a few scenes of stop-motion by Allen, *Laserblast* and his own project, *The Primevals*, are discussed below.

Pamela Bottaro recoils in terror (**left**) from a stop-motion spider constructed for *Planet of Dinosarus*. This particularly effective composite is even more thrilling when you realize that the actress must create her fright and follow the movement of an imaginary spider. The spider, of course, is added many months later.

PHOTO: COURTESY DAVID ALLEN

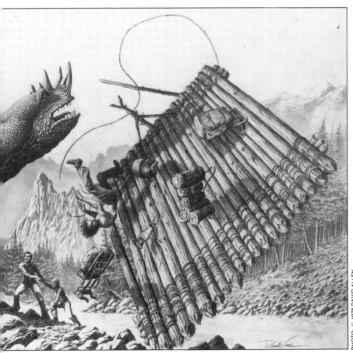

PHOTO: © 1978 DAVID ALLEN

The stop-motion animation for *Laserblast* (**far left**) was created by David Allen and his associate Randy Cook. The personable aliens, rich in character, attracted producer Charles Band to Allen's project, *The Primevals*. *The Primevals* has been a personal project of Allen's for many years and has gone through several stages of evolution, beginning many years ago as a sword-and-sorcery epic, *The Raiders of the Stone Rings*. Now *The Primevals* (**left**) is in production with a script by David Allen and Randy Cook. The "Attack of the River Lizard" is just one of the many preproduction sketches prepared by Cook that highlight key sequences of the proposed epic. The lizard was designed by Allen. *The Primevals* is a very unusual film—David Allen will have complete creative control over the project from start to finish; a situation which is very rare for any single man, let alone the special-effects designer.

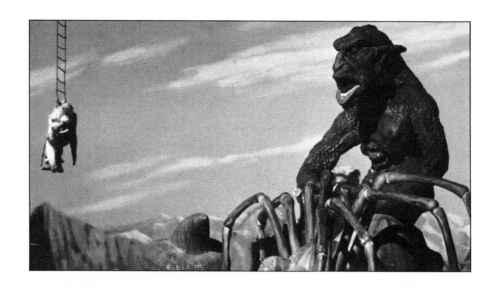

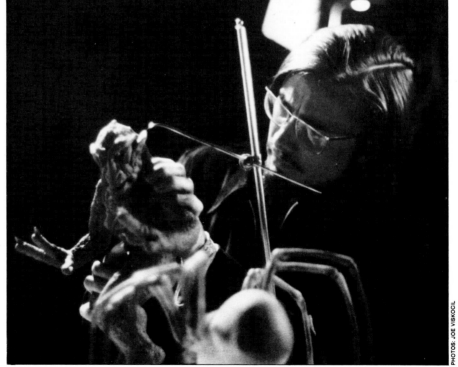

The great god "Porno" in *Flesh Gordon* was animated by Bob Maine, though a few sequences were done by David Allen, who is seen below left. The creature itself went through quite a number of hands. Part of the armature was borrowed from the late Pete Peterson's "Las Vegas monster;" Dave Allen, Laine Liska and Mike Hyatt all worked on it before it was ready for filming. Originally, only twelve animated shots were planned, but that was increased to thirty as the editor began working with the live-action 16mm footage that had been shot almost a year and a half before. The editor wanted more animated footage to use as cutaways from the live action. He would suggest camera angles to Maine, who invented the action to match. At left, the creature has broken off one of the legs of the spider tower ornament. This particular sequence looks easy, but it kept Maine working in the studio long into the night. The spider creature was made of plastic with a wire core. Bob had to saw through the leg a tiny bit at a time, working frame by frame, and moving the creature to make it look as if it was breaking. The plastic on the inside was white, so Maine also had to touch up the inside with copper paint as he went along to make it look like metal. The creature grasps Dale (**below**) which was a little model about two inches tall and made of wire and cast in liquid latex. The model's arms kept breaking, so quite a number of them were made before the sequence was finished. About the creature itself, Maine wished that the ears were armatured so he could get some motion into them as well, since there were so many comic opportunities for ear-wiggling. But the eyebrows and nose were very flexible, as was the mouth. Maine had been told that the creature was to be grouchy and mumbling to himself, so a lot of mouth movement was done, thinking that growling noises would be added. It was decided in post-production, however, to give him a voice. So dialogue was added that matched the movements of the mouth.

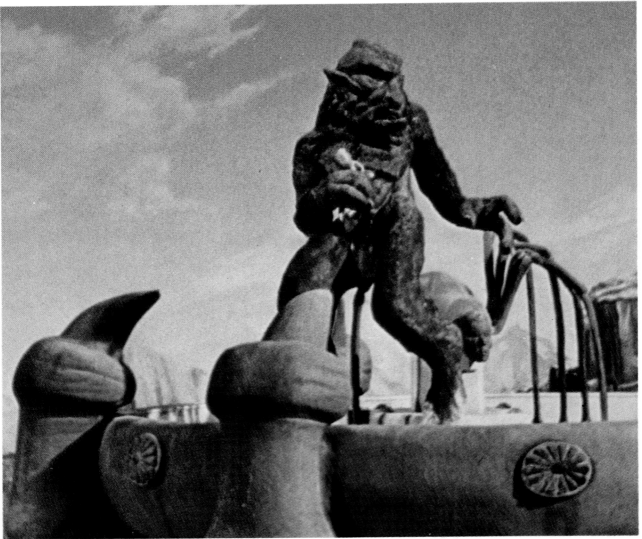

PHOTO: 1974 MAMMOTH

opey, an endearing, but "dopey" dinosaur from *Land of the Lost*, quickly became one of the series' most personable non-human stars—whether hauling a cart load **(upper left)** of giant strawberries for his human friends (and eating them along the way—eating the strawberries, that is) or wandering blithely into a tar pit **(above)**. His human friends try to lasso him out of the pit; a good sequence in script, but a real challenge for the model animator. A "rope" had to be bent out of stiff wire and carefully animated **(lower left)** frame by frame to make it fly across to Dopey and tighten around his neck. Animator Gene Warren Jr. makes use of two surface gauges to keep track of the moving "rope," having both the length of the line and the position of the noose to contend with.

T wo dinosaurs **(far right)** fighting to the death means twice as many headaches for the model animator. Two creatures mean more movements to keep track of and twice as many limbs to move. Therefore, it will take almost twice as long to film this type of sequence as one which involves only a single dinosaur. When the number of creatures to be animated goes up, so does the chance for error. Unfortunately, most errors are not spotted right away. A sequence is filmed, sent to the lab to be developed and printed. The next day look at the previous day's work may reveal all sorts of surprises: a surface gauge left on during an exposure, a lamp blew and went unnoticed, a pair of pliers or a screwdriver accidentally left in the scene. Sometimes a bad frame or two can be deleted or edited around. Other times the sequence must be reshot. Other times simple distraction during a sequence can spell disaster. The telephone rings in the middle of a move. When you return to the shot, you look at the dinosaur and think, "Now was that leg moving up or down before I was interrupted?" You have a 50% chance of being right.

A view **(right)** from behind the camera. Many hours of solid concentration are required to turn out a successful animated sequence.

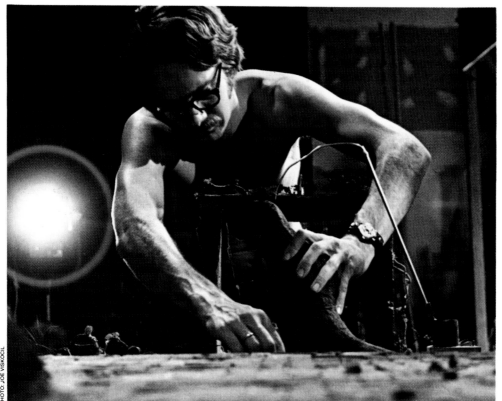

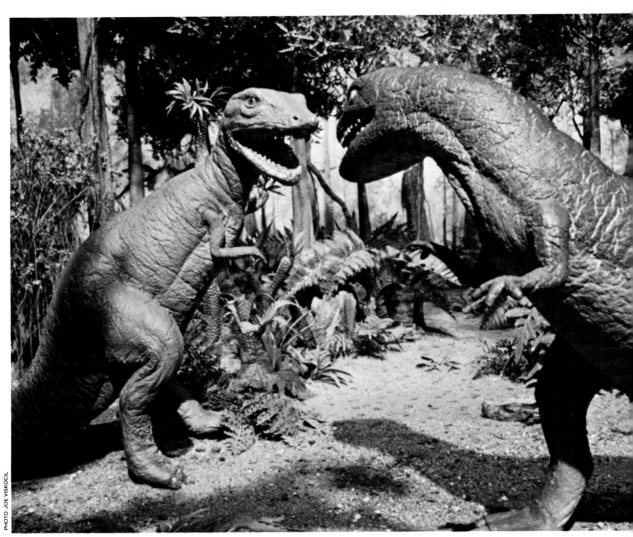

PHOTO: JOE VISKOCIL

Harry Walton **(far left)**, on the set of *Land of the Lost* in Gene Warren's studio, keeps up a steady pace turning out model animation footage for the weekly series. Consider a brief cut of animated effects footage, ten seconds. Ten seconds of film is 240 frames—240 separate exposures. Walton must move the creatures just a fraction of an inch and film the setup one frame at a time—grueling, back-bending work.

Dinosaur and a figure of a man **(left)** side by side give an idea of the scale involved. The series was made for television and made use of its electronic effects capabilities. A studio camera matches up a shot of the live actor that exactly matches the size and position of the little clay figure when the film is set up on a TV monitor. After a few test frames, the little man is removed and the sequence continues with the live actor electronically inserted in the studio.

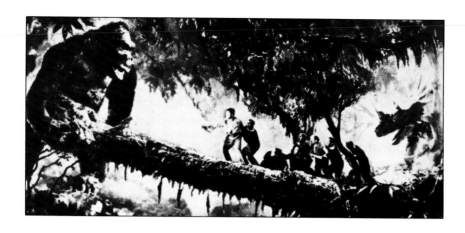

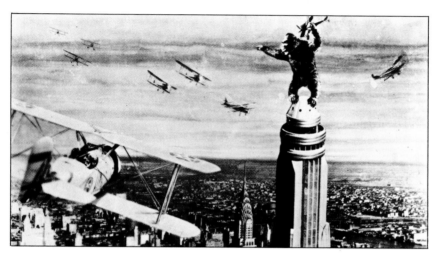

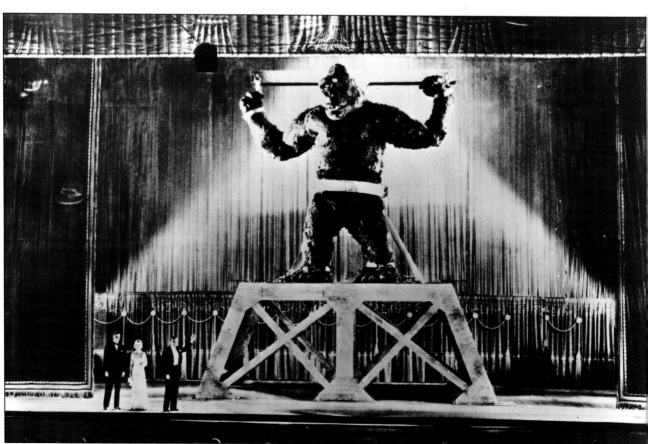

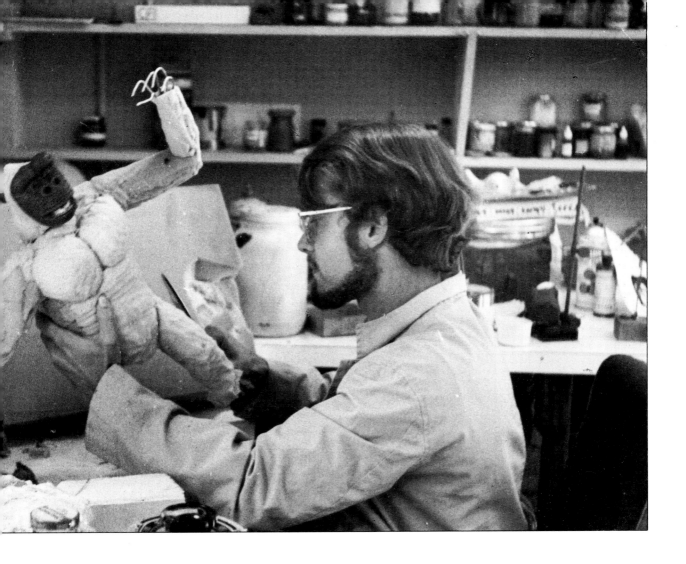

Released in 1933, *King Kong*, filmed at a cost of $650,000, has become the landmark film in stop-motion animation. It was the creation of Willis O'Brien, who has become the father of stop-motion technique in the cinema. O'Brien had been working in the stop-motion technique since 1914 when he worked with Edison's company, and later in the early 20s, with *The Lost World*, completed and released in 1925 after many years, off and on, in the making. After *Lost World*, O'Brien began preliminary work on a number of projects—*Atlantis, Creation* and *Frankenstein*. Merian C. Cooper believed in O'Brien's methods and began to develop the ideas from which Kong was finally born. A test reel was made. One of the scenes was the sequence in which Kong shakes the explorers off a log **(upper left)**. It sold the film to the backers and remains one of the classic moments in film history. No less famous is the finale with Kong perched **(middle left)** atop the Empire State Building, protecting the beautiful Fay Wray and hurling his defiance on man's world. Kong, the eighth Wonder of the World **(bottom left)** remains one of the legends of the cinema. So much so that modern animator David Allen **(above)** was called upon to recreate that last climactic moment of Kong's life. Here he sculpts one of two Kong's that were made at Cascade—one was made for exhibition, the other, a fully articulated model carefully copied from the Marcel Delgado original, was used in the Volkswagon commercial.

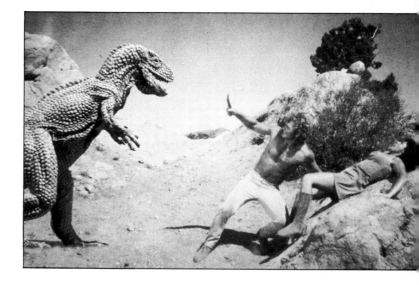

Man against beast **(upper right)**. Allosaurus attacks Chuck Pennington and Charlotte Spear in *Planet of Dinosaurs*. This particular scene is a good example of the composite matting process that is described on page 74. The actors are, of course, fighting thin air—the model dinosaur is added later, frame by frame, matching the movements of the actors. There is an alternative to the composite matting process, however. The most standard is to build a bit of landscape to hide the model tie-downs and supports. Care must be taken to blend the color and texture of the foreground terrain with the full-scale photographed terrain in the rear-projected plate. This is not as easy as it sounds since the original terrain was photographed outdoors in sunlight and the model photography is being done in the studio under artificial light. Matching colors of rocks and dirts becomes something of an art. Doug Beswick **(below, right)** works with a duel-to-the-death sequence on a well-matched foreground terrain miniature.

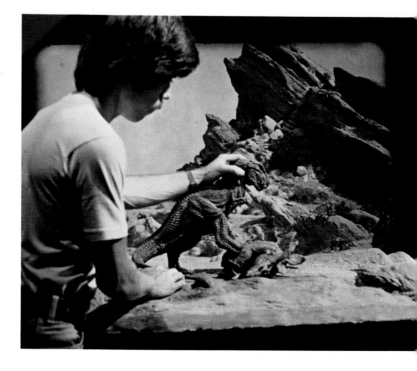

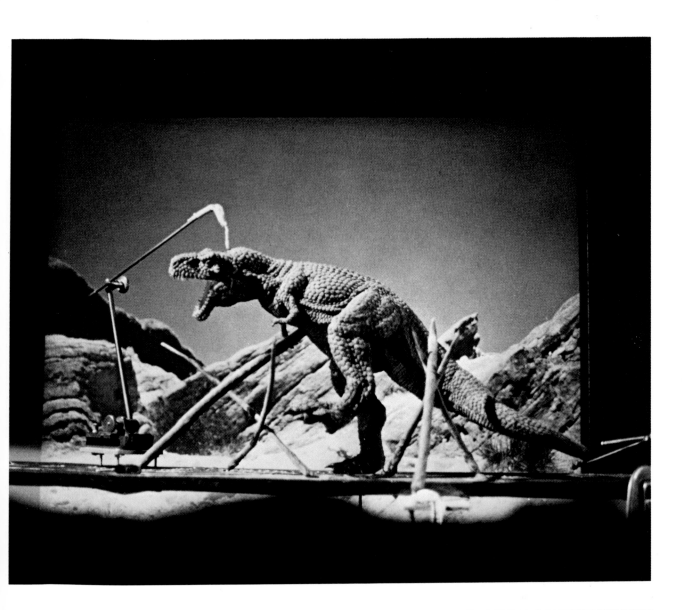

A very angry Tyrannosaurus Rex **(above)** tears his way clear of a miniature stockade. The setup **(right)**, with rear projection and miniature rocks, was by James Aupperle. Animation for this sequence was by Doug Beswick. Such use of miniature foregrounds in rear-projected scenes can add to the realism of the scene. The shadows cast by the model dinosaurs are cast on the miniature rocks. These shadows become part of the scene and add greatly to the reality of the sequence—not only do you see a dinosaur marching across a rock-strewn landscape, but you see his shadow moving over those rocks!

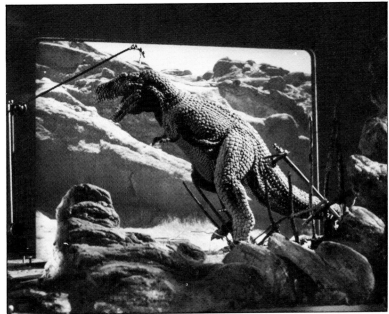

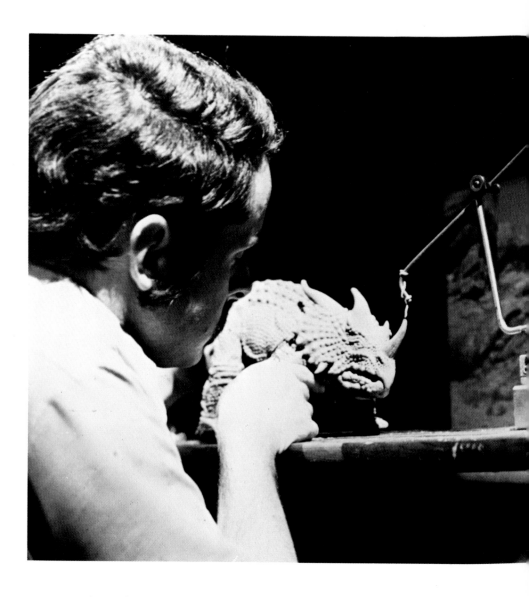

J ames Aupperle **(above)** is working on a sequence from *Planet of Dinosaurs* that involves the
combination of live action with model animation. The live-action frame can be seen rear-
projected on the screen in the background. A surface gauge is positioned at the tip of the dino-
saur's horn to keep accurate check on the movement from frame to frame. Use of such guides is fair-
ly critical when combining live action with model animation.

At the edge **(upper right)** of the cliff, the dinosaur has chased one of the explorers over the edge. A
small model figure has been fastened to a C-clamp and is being animated frame by frame in his fall
from the top. This particular method is very handy as it obviates the need for expensive and time-
consuming aerial brace work. The tie-down frames, braces and brackets are taken out by the use of a
matte.

The finished composite **(right)** is achieved by first filming the model and background with a black
painted matte or mask blocking the support frame work of the model. After the sequence has been
filmed, the film is rewound. On the second pass through the camera, a second matte or mask is
placed in front of the camera that is the exact compliment of the mask that was used in the first pass.
This time the model and its framework is removed and the bottom part of the rear-projected plate is
recorded on that area that was left unexposed in the first pass. The upper part of the frame that was
filmed on the first pass is blocked out by the second mask. The result is a complete scene, with the
dinosaur appearing to be in the middle of the live-action scene.

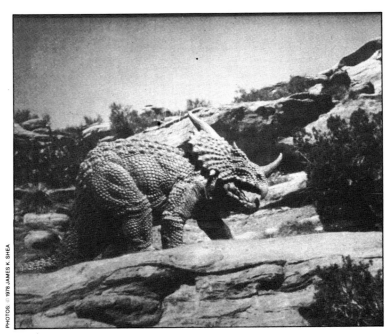

Ray Harryhausen **(below)**, acknowledged master magician of stop-motion animation, displays one of his models from his first Sinbad film, *The 7th Voyage of Sinbad*. The evil magician Sokurah transforms the Princess' maidservant into a four-armed dancing snake woman. The sequence is still one of Harryhausen's favorites.

Mysterious Island **(right)**, released in 1961, was a departure from the Sinbad series. It was based on the Jules Verne novel of the same name. The crab sequence was one of the highlights of the film. Special-effects films require many months and even years of careful pre-planning. Very often, elements of a scene will be shot months apart—some on location and other sequences in a studio. These different elements must match perfectly to maintain the illusion. Generally, a number of continuity sketches **(middle right)** plot out exactly how each scene in any given sequence will be accomplished. These continuity sketches let the actors see what they are supposed to be doing and allow the director and cameraman to make special allowances for the material that will be added optically later. The thrilling finished scene **(bottom right)** is the payoff of years of planning and effort.

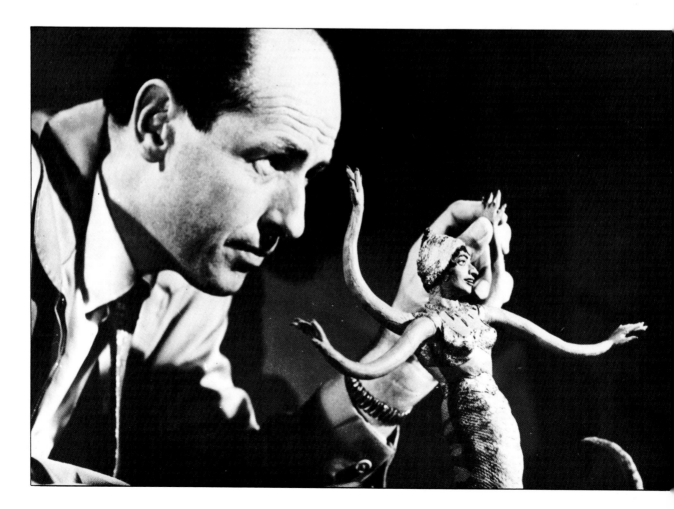

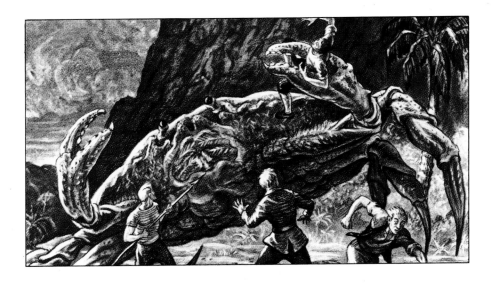

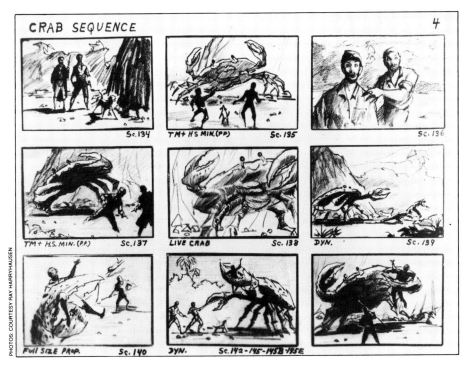

CRAB SEQUENCE 4

Sc. 134	TM + HS MIN. (P.P.) Sc. 135	Sc. 136
TM + H.S. MIN. (P.P.) Sc. 137	LIVE CRAB Sc. 138	DYN. Sc. 139
Full Size Prop. Sc. 140	DYN. Sc. 142-145-145B-145E	

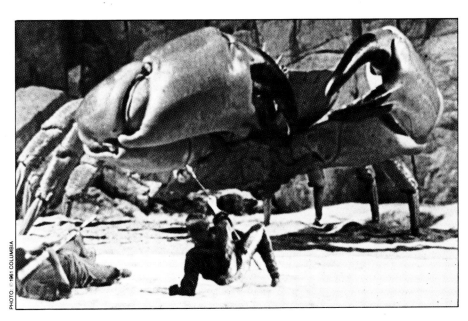

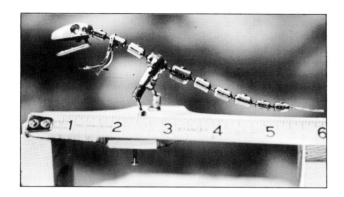

Dinosaurs from the inside out. Gene Warren's Excelsior Animated Moving Pictures built the model dinosaurs for the TV series *Land of the Lost*. Television has only a fraction of the resolution potential of the motion picture, so the little creatures could be far less detailed. Also the series generally had two different sort of dinosaurs—those that were "cute" and friendly and those that were ugly and mean. The actual construction is only as complex as the demands being made on any single creature. The dinosaur illustrated above is fairly simple, as these things go. The armature skeleton is basically ball-socketed joints. The forelimbs do not require extensive realistic animation, so short lengths of twisted wire will serve. A short length of wire also finishes out the tail. It is important not to build more than you are actually going to need in a given situation. Only that which is going to be seen by the audience is made as detailed and finished as time and money will allow. After the armature is assembled, foam latex is cast around the creature. Final touches consist of painting, texturing, and adding details such as eyes. The little fellow seen above seems quite pleased with himself and seems to be just waiting for someone to take him home.

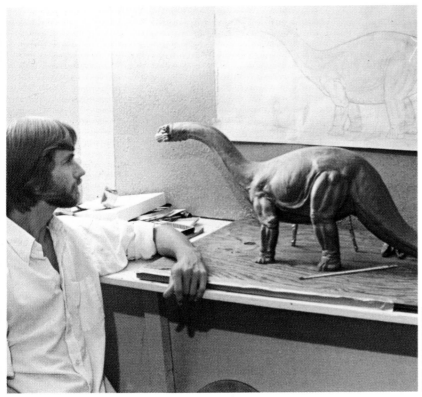

Dinosaurs designed for *Planet of Dinosaurs* were of the hostile, bad tempered and very real variety. The scaly creature at left has been posed next to the section of the mold from which he was cast—very much as if he had just hatched from the egg. The ball-and-socket armatures for these creatures were constructed by Victor Niblock. *Planet of Dinosaurs* is the first professional full-length motion picture for Executive Producer Stephen Czerkas, pictured below. Czerkas can be seen with his realistically sculped Brontosaurus. The original drawing hangs on the wall just behind the sculpture. Such marvelous detailing, as is visible in his model, is done only for the theatre screen in which the film is blown up many hundreds of times on the screen. Such detail would be invisible on television. Czerkas and Associate Producer James Aupperle are also known for their stop-motion sequences in the TV series *Jason of Star Command*, a live-action Saturday morning series with stunning visual effects.

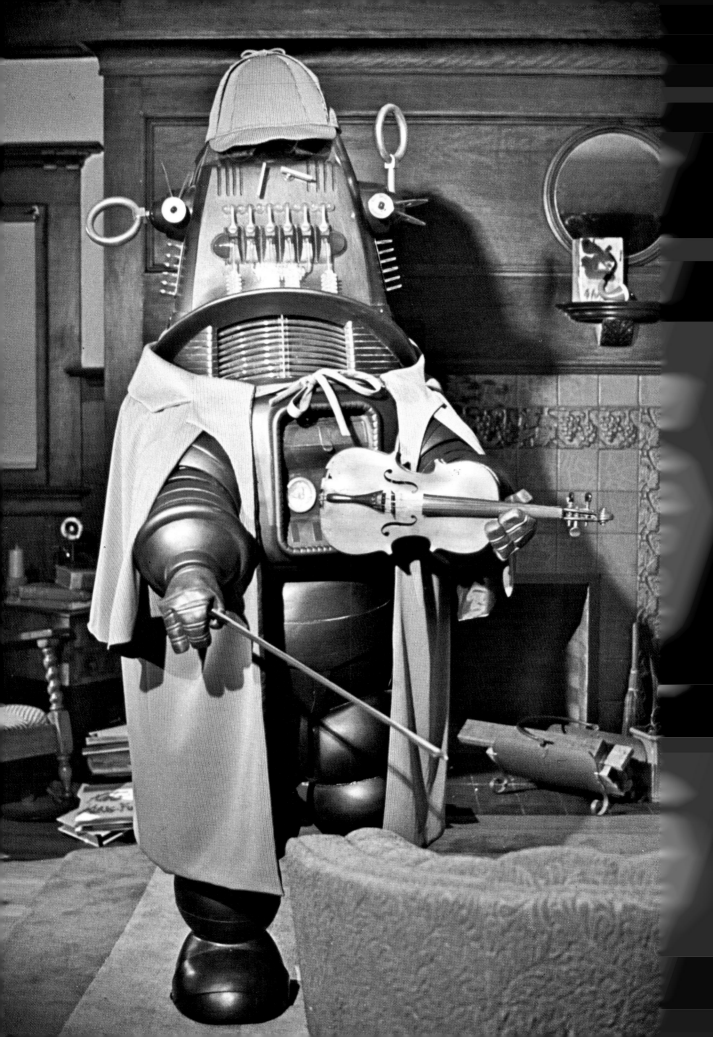

Hardware Greats

Robby

Few creations in SF film history have been as enduring as Robby the Robot. Conceived for M.G.M.'s first foray into science fiction, *Forbidden Planet*, Robby came an overnight sensation. Robby has made appearances through the years in many different types of programs—everything from the *Gale Storm Show* to *Project: UFO*. Essentially his persona of awesome physical power and amiable alien intelligence has been preserved, largely due to the loving efforts of Bill Malone. Robby had been junked by M.G.M.—stripped, gutted and sold to the Movieworld Museum. It was Bill Malone who researched Robby's design and after visiting the lifeless shell at the museum, decided he could be rebuilt. "A robot never really dies," says Bill, "he can always be rebuilt!"

Robby in cape and deerstalker **(left)**, with violin in hand, thinks he's Sherlock Holmes. In a pilot directed by Bill Malone, entitled *Homes and Walston*, Jerry Mathers as Walston inheirits Robby who has been programmed with 3,000 volumes of *Sherlock Holmes*. When Walston activates Robby, he thinks he *is* Sherlock. In a more alien guise **(above)** Robby appeared on *Project: UFO*. Dr. Edward Morbius **(above right)** demonstrates in *Forbidden Planet* how Robby's ability to reproduce synthetic molecules identical to the sample introduced through the slot in his midriff. Since Robby is able to reproduce the molecules in *any* quantity, he manufactures synthetic foodstuffs for Mor-

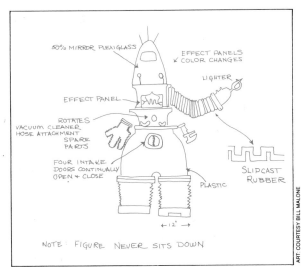

50% MIRROR PLEXIGLASS

EFFECT PANELS & COLOR CHANGES

LIGHTER

EFFECT PANEL

ROTATES

VACUUM CLEANER HOSE ATTACHMENT

SPARE PARTS

FOUR INTAKE DOORS CONTINUALLY OPEN & CLOSE

PLASTIC

SLIPCAST RUBBER

←12"→

NOTE: FIGURE NEVER SITS DOWN

An early sketch **(above left)** by A. Arnold Gillespie delineates the basic form of the robot, though the details evolved considerably. Originally, Gillespie had envisioned Robby with interchangeable tool-like hands that would perform various specialized tasks. Six different designs were suggested—one of which called for a beverage dispenser with a dial to select whatever kind of drink was desired. Another had a cigarette-lighter finger. Robby appeared on an episode of *Ark II* **(above)**. It was contemplated that Robby might be a good addition to the *Ark II* regular staff, but in the episode he is not trusted as being a "good" robot and must prove himself, which he does by saving a village from a poisonous gas. Unfortunately, he destroys himself in the process. Again Robby was cast in the sort of sympathetic role for which he is most famous: the tool that mankind cannot turn against itself.

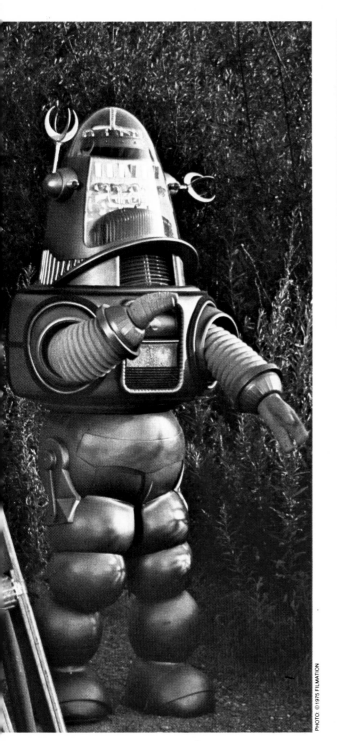

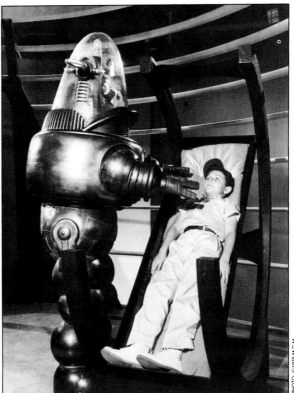

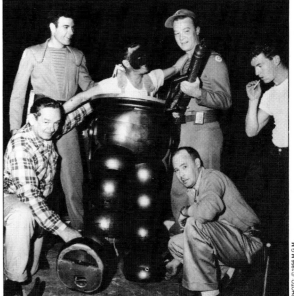

In M.G.M.'s *The Invisible Boy*, **(top)**, which followed hard on the heels of Robby's debut in *Forbidden Planet*, the robot was cast as a heavy. This perversion of the original concept did not go over well; fortunately most of Robby's other appearances have remained true to his designer's intent. Frankie Darrow **(above)** suits up on the set of *Forbidden Planet*. His face is blacked out so as not to be visible behind the neon tubing in close-ups. The original electrical work was done by Jack McMasters, with plastic construction by Cliff Grant and Rudy Stengler. The shell consists almost entirely of vacuum-molded plastic with a small number of machined aluminum fittings, grips and rails. Even with this extensive use of plastic (M.G.M. had just acquired a plastic vacu-former and was trying it out on everything in sight), Robby weighs in at a bit over one hundred pounds.

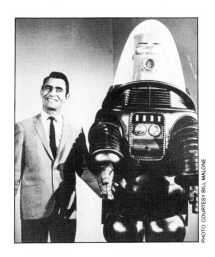

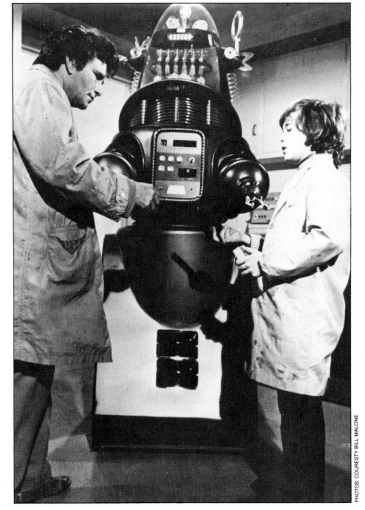

R od Serling **(above left)** poses with R
in one of his "makeups" as he appear
Twilight Zone. Robby was nearing the
of his life as an M.G.M. property at this tir
 Robby, shortly after he had been reborn
the skilled hands of Bill Malone, appeared in
of Bob Burns' famous Halloween shows in a
ated sequence from *Forbidden Planet.* The
morning Robby's picture appeared in the *L.A.*
prompting a call from Universal Studios.
wanted to feature him in a *Columbo* ep
(left), "Mind Over Mayhem." Bill created the c
modifications at the request of the show's proc
who were afraid that Robby might up
Peter Falk.

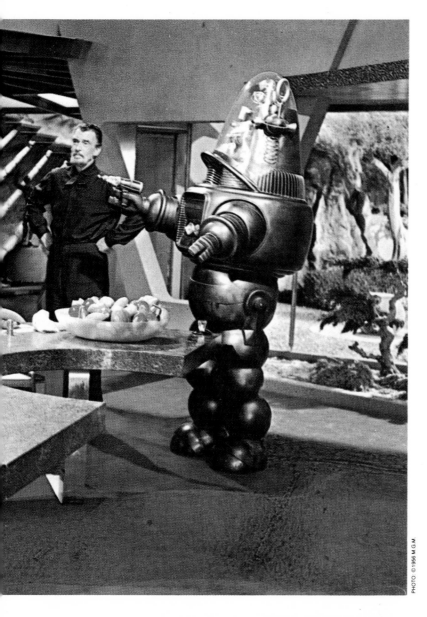

At the home of Dr. Edward Morbius **(left)** on Altair IV, Robby demonstrates his basic inhibition against harming rational creatures, using Commander J. J. Adams as a guinea pig. Morbius first instructs Robby to aim the pistol at a shrub on the patio and fire. The shrub vanishes in the pistol's beam. Then Robby is told to aim the pistol at Adams—right between the eyes. At the command to "fire" a curious grinding sound and sparking of lights seems to make the entire machine tremble, visibly, but Robby's hand cannot (or will not) close on the trigger. Morbius explains, "You see, he's helpless. Locked in a sub-electronic dilemma between my direct orders and a basic inhibition against harming rational beings. If I were to allow that to continue, he would blow every circuit in his body." This scene forever imbues Robby with his most winning characteristic—benign power. An awesome force that can never be used for evil. Robby **(lower left)** is the driver and power source for a car designed by A. Arnold Gillespie.

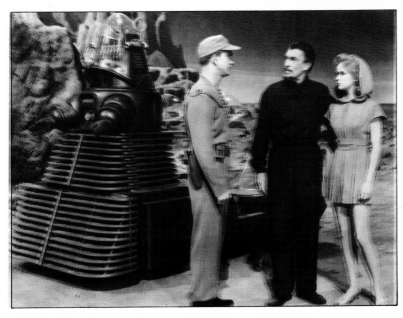

Saucer C-57D

M.G.M. has a reputation for first-class production values. With *Forbidden Planet* being its first foray into the science-fiction world, a budget of $1,900,000 was set aside for the film—unusual for SF films in the post WW II era. Special-effects directors A. Arnold Gillespie and Warren Newcomb, art director Arthur Lonergan and set designer Hugh Hunt were intrigued with the challenge of creating a whole new solar system. UFO sightings were still hot news, so the saucer shape was agreed upon very early. Much of the design, including the interior, was developed with the advice of scientists at Cal Tech, though much of the final interior design, crew quarters, astrogation equipment, faster-than-light drive was established by Bob Kinoshita. Three models for various sequences were built, as well as a full-scale set piece of the lower half of the saucer, which measures about 60 feet in diameter.

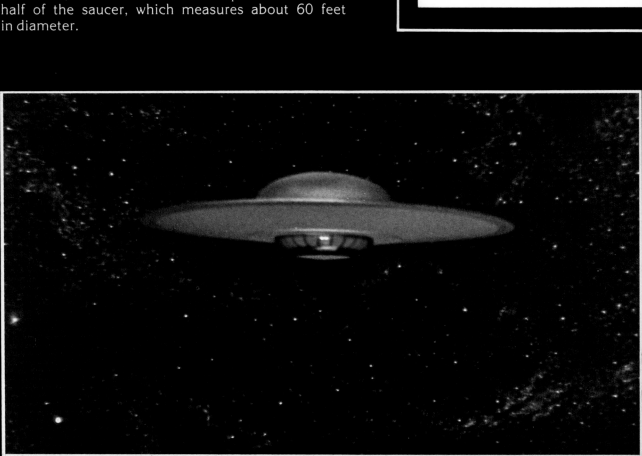

PROVIDE RED GLOW IN THIS AREA
AS PER INSTRUCTIONS

LANDING GEAR & PORTS OCCUR
ONLY ON SHIP #3
(SEE DETAILS)

1671-70
EXT. SPACESHIP
SH-2-

SHIP #1
SCALE: FULL SIZE

A starcruiser by design, United Planets *Cruiser C-57D* **(left)** is journeying from Earth to Altair, one of the suns in the constellation Aquila. At the beginning of the film, the cruiser has accelerated to a top speed of 600 million miles per hour and has been in space for over 356 Earth days. It is noted in W. J. Stuart's novel of the film, that even if the cruiser returned to Earth immediately, the crew would have spent 24 months of their lives on the round trip, but friends and family back on Earth would have aged 20 years! Both scriptwriters and designers went to great lengths to lend an air of scientific plausibility to the film. It is, of course, a plausibility that only exists within the context of the film. Nevertheless, such terms as Quanto-Gravitic drive and "klystron modulator," while entirely fictitious, add greatly to the atmosphere of the film. An interesting sequence at the beginning of the film involves the transition of the saucer from faster-than-light hyperspace to below light-speed normal space. The crew is called to "D-C" stations just before the ship decelerates to the speed of light. All crewmembers stand rigidly under individual beams of radiation that envelop their bodies in a greenish glow. As the crew slowly fades from visibility in the glow, a pulsing sound grows in intensity as the control deck of the saucer darkens to an odd russet color. Finally the lights return to normal, the green glow fades from the crew, who then return to their stations.

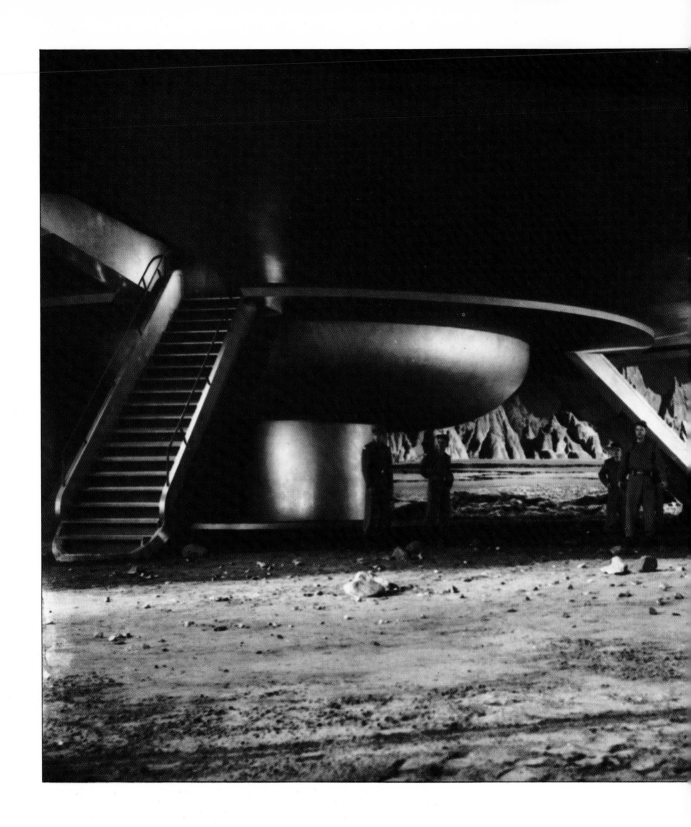

The crew of United Planets *Cruiser C-57D* (**above**) stands under the protecting rim of the saucer. The rock-strewn surface of Altair IV blends perfectly with George Gibson's 350-foot cyclorama depicting the distant landscape. The landing sequence was executed in miniature and designed by Arthur Lonergan. The shot begins with a vista of Altair IV, the planet's twin moons hanging in the sky. The saucer moves across the CinemaScope frame, circles and begins to descend vertically. As the ship nears the surface, static discharges flash from the ship to the ground. From the central core, which is spinning with a light effect, a large mushroom pedestal slowly descends. After landing, twin stairways drop from the saucer as the crew disembarks.

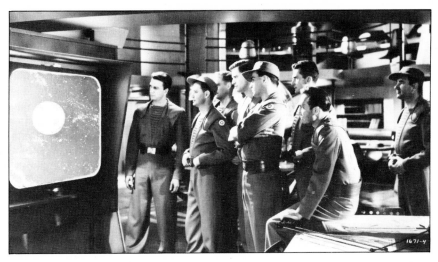

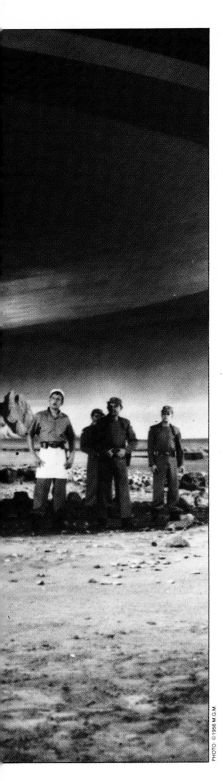

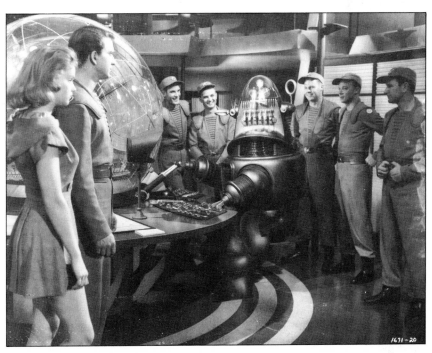

The interior design of the saucer has held up remarkably well over the more than two decades since its release. With the advice of Cal Tech scientists, Bob Kinoshita's personal artistic vision and the early production art of Irving Block, instrumentation was developed that was so unique and practical looking that audiences of today are stunned. The multistory control room was rigged with fire-pole-like lifts to move the crewmen from level to level and opened directly into other areas of the ship—quarter's for the crew, communications center, view-screen and astrogation area **(above)**, "D-C" stations—all remarkably real and well thought out. Gone were the steamroom fittings, dials and office chairs tucked behind scrapped together "control panels" which inevitably looked out through enormous port holes that were a 50s stereotype. The pilot's station **(below)**, with Robby at the controls, is a unique design whose instrumentation will never be datred. Robby, incidentally, is shown seated—something he was not designed to do. The legs are cardboard cutouts with only the robot's torso and head actually being used.

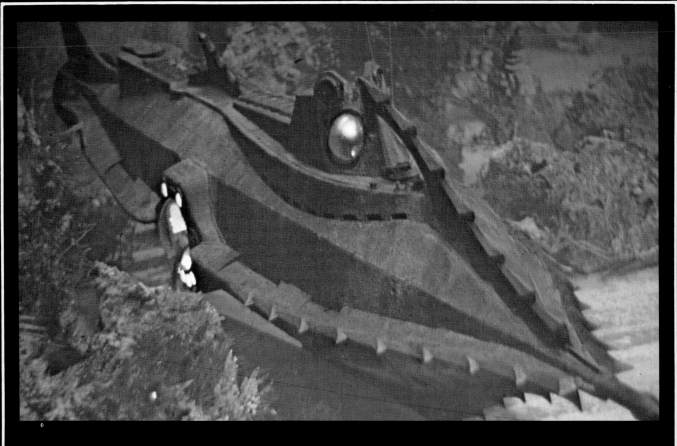

The Nautilus

Jules Verne started the first draft of *20,000 Leagues Under the Sea* in 1867 while outfitting his yacht, the *Saint-Michel*. A bit of Nemo is revealed in Verne's affection for the *Saint-Michel*: "I am in love with this assembly of nails and planks the way one is in love with a mistress when one is twenty!" (From his biography by Jean Jules-Verne.) The novel was completed in 1870 and translated into English in 1873. It was an immediate success.

The film, released in 1954, was Disney's first full-length, live-action motion picture produced in the United States. It was also the second CinemaScope picture to go into production. Disney was famous for pushing his staff to the new, the untried, the experimental. For Harper Goff, the film's designer and driving force, it was the project of a lifetime. Mr. Goff remembers: "I was assigned the task of getting together a 'true-life adventure' film using some exceptional footage, shot in a laboratory aquarium by Dr. McGinnity of Cal Tech's marine biology lab in Corona Del Mar. Walt thought that inasmuch as *20,000 Leagues* was in the public domain, we might do worse than to use the title for our 'true-life adventure' short subject. Walt went to England, while I stayed in Burbank storyboarding a live-action version of the classic, using McGinnity's footage as a sort of ballet episode in which Nemo shows Professor Aronnax the wonders of the deep. Walt liked the storyboard well enough to give me an 'A.R.I.' (audience reaction inquiry) to a group of exhibitors who were in town. They were enthusiastic—and the rest is history."

In 1797, Robert Fulton built an experimental submersible, christened the *Nautilus,* which underwent extensive testing in 1801. It was in honor of Fulton's early efforts that Verne named Nemo's famous submarine. At left are the exterior and interior of the *Nautilus* as designed by Harper Goff. The exterior view is of one of the models constructed for the tank sequences. As no full-scale, operational version of the sub was built, most of the underwater sequences of the *Nautilus* gliding through the depths were shot in a studio tank. Below, the grand salon with its famous pipe organ—Nemo's only solace aside from the sea itself. The intricate pipes and ornamentation were sculpted by Chris Mueller, a craftsman of long-standing distinction. Such scupture in plaster is almost a lost art today. The insides and outside of the sub were taken from Verne's own descriptions. Roy Disney had proposed a sleek, cylindrical shape—a very modern design. But Goff believed that the submarine design should evoke the technology of the day in order to be believable. He also held that the book was a classic and that ". . . in motion pictures, the text of a classic like this is sacrosanct, like the *Bible*. The 'word' of Jules Verne is not to be made light of so the duty of the designer like myself is to take the sometimes arbitrary descriptions of the *Nautilus* as recorded by Verne and 'make it work.' "

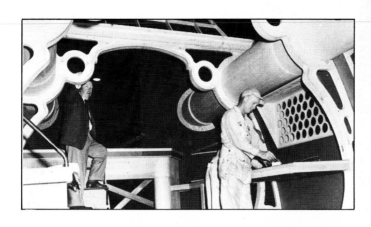

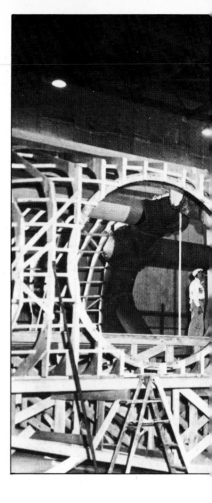

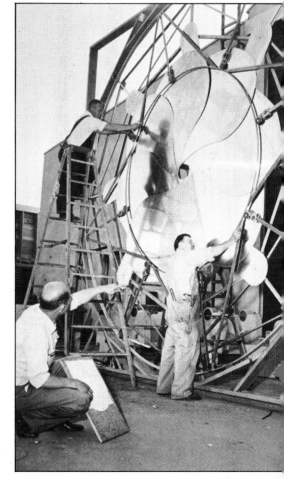

H arper Goff (**above**), in the dark jacket, oversees the construction. The illustrations above show angles of the chartroom, just below the wheelhouse, in construction. At right is the enormous iris that opens Nemo's bay-window view of the depths being tested. Designer Goff comments on the background of the design: "One of the most awe-inspiring, iron engineering structures in the world is the cantilevered bridge across the Firth of Forth in Scotland. One of the world's greatest railroad bridges, it was constructed of giant, tapered iron tubular columns and trusses. These hollow tubes were easy to erect—lightweight in proportion to their strength and could be filled with rock to become heavy enough to ward off the channel winds. I designed the tubular skelton of the *Nautilus* with similar "unions" joining the tubes and provided that the upper spaces in this hollow structural frame should be used to store the air while the lower voids would be a water ballast. An interesting sequence in which this all was explained to Arronax by Nemo was eliminated because it was too time-consuming. Alas."

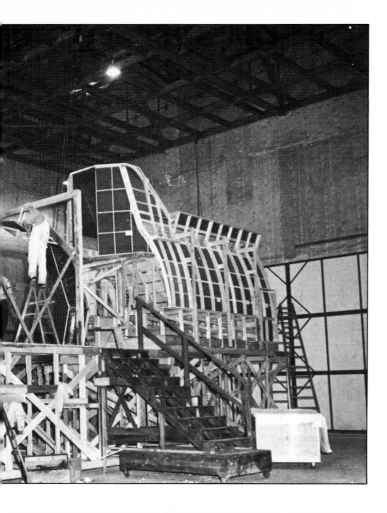

The skeleton of the *Nautilus* (**left**) begins to fill the Disney sound stage. The great "bay window" to the sea stands prominently on the side of the set. Harper Goff (**middle left**) pauses just inside the "window" with part of the enormous ballast skeleton visible at the left of the picture. The great "eyes" (**below left**) are in the forward section of the wheelhouse. Goff comments on the "sea monster" aspect of the craft: "Early reports of the destruction of ships described a so-called 'sea monster' of terrible speed and tremendous power, with great glowing eyes, a great dorsal fin and a tail which churned the sea into a froth when it attacked its victims. It would ram ships with such speed that it passed clear through its prey—usually leaving the broken hulk in two parts. My idea has always been that the shark and the alligator were the most terrifying monsters living in the water. I therefore borrowed the scary eye of the alligator that can watch you, even when the alligator is nearly submerged. Then there is the dangerously pointed nose and menacing dorsal fin, its sleek streamlining and distinctive tail. The disgusting, rough skin of the gator is well-simulated by the rivets and barbed protuberances that cover the sub. As Verne insists that the *Nautilus* drove its way clean through its victim, I designed a protective, saw-toothed spline that started forward at the bulb of the ram and slid around all the outjutting structures on the hull. These include the conning tower, the diving planes and the great helical propeller at the stern.

A section of the *Nautilus* **(right and below)** was built and attached to the U.S. submarine *Redfish* for the sequence in which Nemo begins to submerge, with Ned Land and Professor Arronax clinging to the structure. The plate and rivet design is very much in evidence. "At the time Nemo constructed the *Nautilus*," Goff explains, "the iron rivet ship was the last word in marine construction. I have always thought that rivet patterns were beautiful. On Volcania, Nemo had the white-hot heat of the volcano to help him build his dreamship, but I am sure that flatiron plates, profusely riveted, would have been his way. His stockpile of materials was always the countless sunken ships uniquely available to him alone."

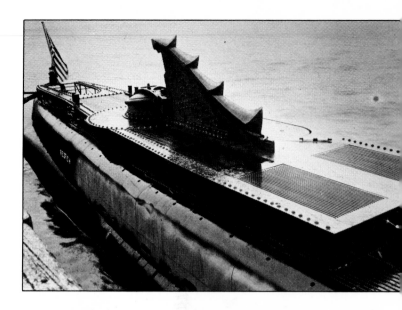

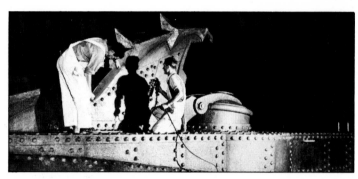

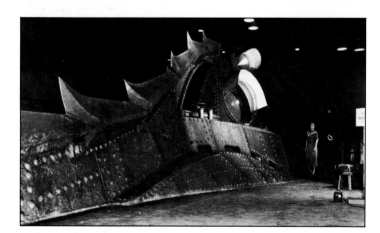

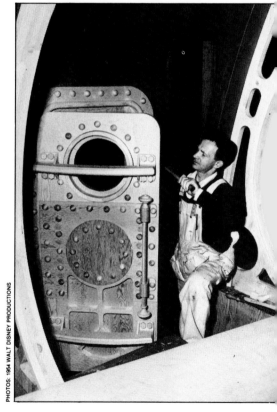

The rivets, structural shapes and iron work were hand-cut from plywood or turned on a lathe **(above)**. "I wanted no slick-shelled Moonship to transport Captain Nemo through the emerald deep," says Goff. The blueprints at right reflect his wishes. Concerning the source of power for the craft, Goff points out that "Nemo is quoted by Verne as telling Arronax that need no coal for my bunkers. I have instead harnessed the very building blocks of the material universe to heat my boilers and drive this craft.' No one can doubt that Verne meant atomic power."

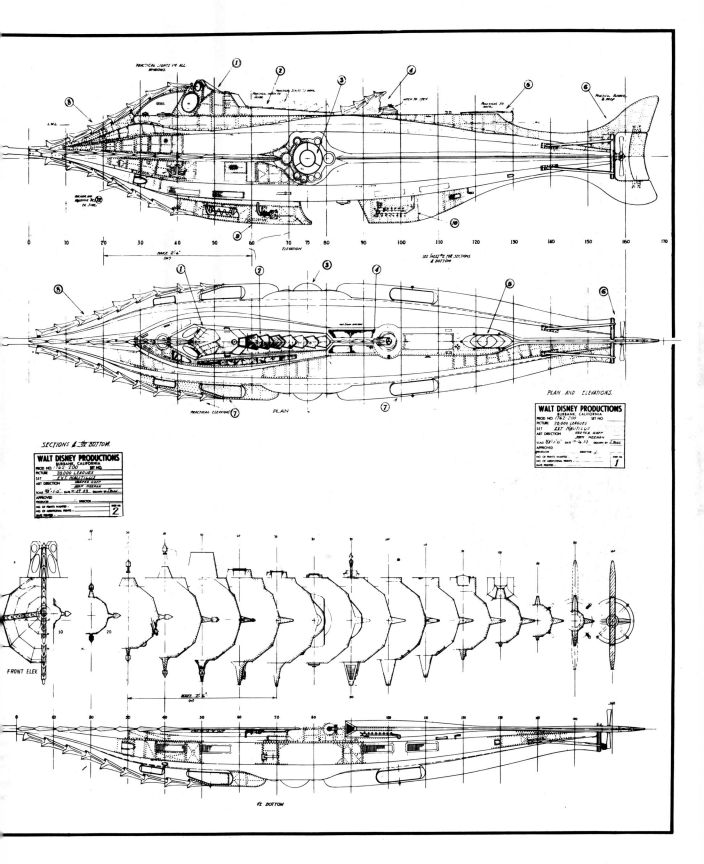

WALT DISNEY PRODUCTIONS
BURBANK, CALIFORNIA

WALT DISNEY PRODUCTIONS
BURBANK, CALIFORNIA

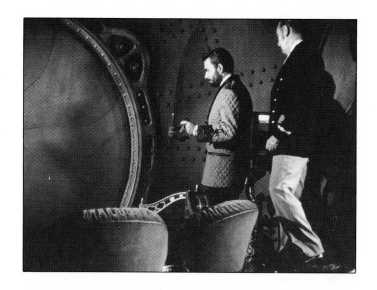

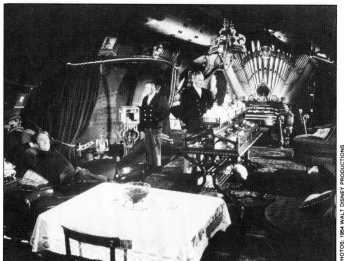

In a way, it was the personality of Nemo that determined a good deal of the design. "Jules Verne," concludes Goff, "while foreseeing brilliantly the atomic submarine of today, did not at that time invent the periscope, the torpedo tube, or sonar. He did not prophesy closed-circuit television. According to Verne, if Nemo wanted to see what was going on on the surface, he simply poked the glass ports of the conning tower out of the depths and took a direct look. Neither would it have been true to Capt. Nemo's nature to skulk along and fire an armed torpedo at his enemy. He risked his vessel and himself and crew by ramming the enemy at frightening speed. If he wanted to study the marvels of life beneath the surface, he reclined in his elegant bay window lounge and passed the hours studying the marine life outside of his luxurious salon. These items dictated much of the direction of my designs."

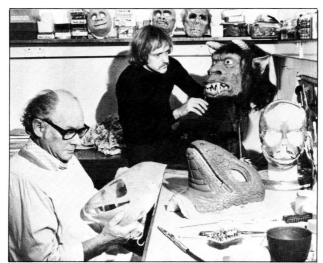
Meet Stewart Freeborn, *Star Wars'* alien creator, in his shop.

See how an ice-and-snow set was built in the 102° Sun on the island of Malta.

Special Effects, Volume 2 will continue its behind-the-scenes photo tour of special effects in the making. Volume 2 will explore the fascinating world of the optical printer, the machine that combines flying saucers and planets, miniature dinosaurs with live actors. See the different processes used in Disney fantasy films and hardcore science fiction. Included will be a look at some of the great makeup artists and how they put together their famous creations...a look at the production value-boosting art of matte painting...a behind-the-scenes exploration of the creation of large-scale effects in live-action scenes with snow, fog, rain, etc. All this and more—coming soon from STARLOG magazine.